C000077228

NORTH SHIELDS
THROUGH TIME

North Tyneside Libraries

Diane Leggett *&* Joyce Marti

AMBERLEY PUBLISHING

First published 2013

Amberley Publishing
The Hill, Stroud, Gloucestershire, GL5 4EP
www.amberley-books.com

Copyright © North Tyneside Libraries, 2013

The right of North Tyneside Libraries to be identified as
the Author of this work has been asserted in accordance
with the Copyrights, Designs and Patents Act 1988.

ISBN 978 1 4456 1355 0 (print)
ISBN 978 1 4456 1362 8 (ebook)

All rights reserved. No part of this book may be reprinted
or reproduced or utilised in any form or by any electronic,
mechanical or other means, now known or hereafter
invented, including photocopying and recording, or in
any information storage or retrieval system, without the
permission in writing from the Publishers.

British Library Cataloguing in Publication Data.
A catalogue record for this book is available from the
British Library.

Typesetting by Amberley Publishing.
Printed in Great Britain.

Introduction

From its rural beginnings as a fishing port attached to the priory, with farms inland and later collieries, North Shields has grown into a larger, built-up area with shopping and tourism – especially with the expansion of the cruise terminal at Royal Quays and the large, attractive beaches along the coast.

Originally, transport links relied on trams, the vehicle ferry and railways. But these have been replaced with excellent bus, ferry and metro services, enabling easy access to the coast, Newcastle, South Tyneside, and Gateshead and Metrocentre.

The First World War left most streets in North Shields sparse, a result of the loss of large numbers of young men.

Slum clearance programmes of the 1930s brought people from the crowded, unsanitary banks of the quayside to the town, which was formerly the domain of rich businessmen, into newly built council estates on the outskirts.

The Report of the General Board of Health (the Ranger Report) as far back as 1851 detailed the lack of facilities and overcrowding on the quayside banks. New housing offered inside toilets and a bathroom, eventually rendering the public baths and wash houses redundant. People living in the central area of the town in tenements – former houses of the rich had been divided into rooms and let out to families – were still housed in overcrowded and poor conditions, often with outside toilets and a tin bath in front of an open fire.

After the war every opportunity was taken to post huge advertising boards for cleaning products and foodstuffs, as well as local cinema bills, to brighten the ends of the houses still standing or sites left empty from bomb damage, and inject hope and colour into the lives of the townsfolk.

Whole sections of the town have been rebuilt: the Beacon Shopping Centre has pride of place in the central area of North Shields; the bottom of Howard Street and along the riverside has been, or is being, rebuilt; and the Fish Quay is currently a conservation and regeneration area. The frontage of listed or local heritage buildings has been retained and new builds have, for the most part, been sympathetically constructed to blend with the existing architecture, enabling Shields folk to live in quirky and exciting flats in the town or overlooking the now fairly peaceful mouth of the River Tyne.

We have tried to recreate a walk around the town, starting on the quayside then as far west as Howdon Road, through the town centre, down to the Bank Top and back up to the east along Albion Road towards Chirton.

Acknowledgements

Thanks to Eric Hollerton for collecting material and images to enable us to compile this book, and for his advice and guidance in identifying some of the sites.

Thanks to Kiera Fairley and Kylie Marti for supporting Joyce in taking current photographs.

Thanks to Mr Alan Beautyman for his help with research and for use of some of his photographs.

Thanks to *News Guardian*, *North East Press*, for allowing us to use some of their images from the *Shields News*.

Thanks to other customers who have donated images in the past, some of which have helped with this publication.

If anyone has further information or would like to donate materials to the Local Studies Department please contact Discover North Tyneside Local & Family History Service at North Shields Library or email local.studies@northtyneside.gov.uk

No part of this book can be reproduced without permission from North Tyneside Libraries Local Studies Department.

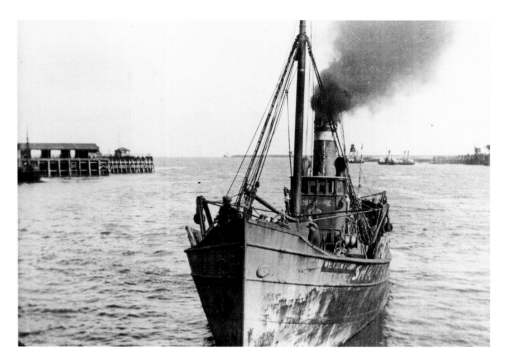

Vessels at the Mouth of River Tyne

Steam trawler *William Purdy* approaching the Fish Quay around 1930 and modern tug *Phoenix Cross* from Teesside making the same journey in February 2013. *William Purdy* SN92, one of the Purdy fleet of fishing trawlers, was requisitioned for war service on 23 January 1940. William Purdy was born in Norfolk in 1836 and became the pioneer of steam trawling from the Tyne in North Shields in 1877. The fleet had green hulls with black funnels bearing a narrow white band.

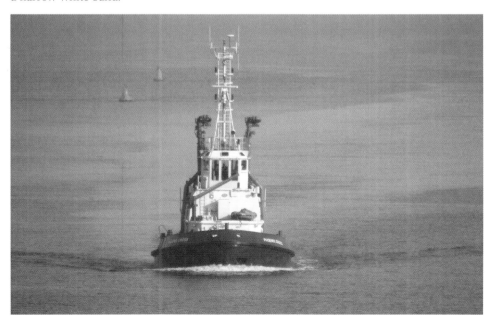

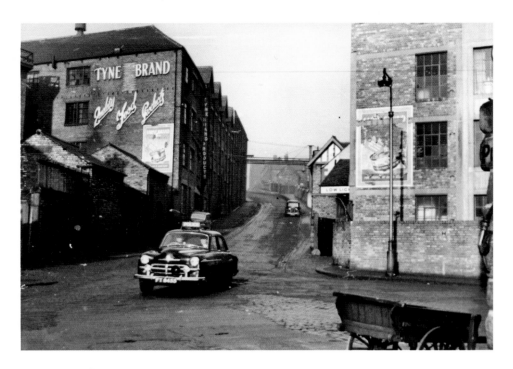

Brewery Bank

Looking up Brewery Bank, or Brewhouse Bank, from Union Road in January 1955, the police car is passing Tyne Brand products factory warehouse on the left and the bridge across to the fish canning factory behind the Low Light Tavern, which was originally a house and is now a Grade II listed building. The gated entrance to the Irvin Building, which has been refurbished into private luxury flats, can just be seen on the left.

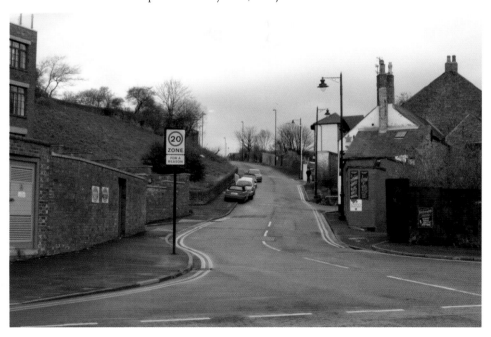

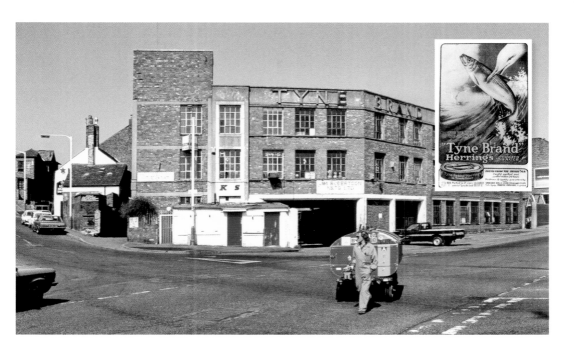

Tyne Brand Factory

Part of the Tyne Brand factory at the corner of Union Road in 1994 was latterly used as office space and premises for firms such as Jim Robertson's Nets Ltd. The factory was well known throughout the country for its canned fish and meat products. Tyne Brand herrings and 'So Taistee' stock were widely advertised on buses and hoardings. The Low Light Tavern, the white building with the distinctive blue star sign, is still at the bottom of Brewery Bank. *Top image ©A. H. Beautyman.*

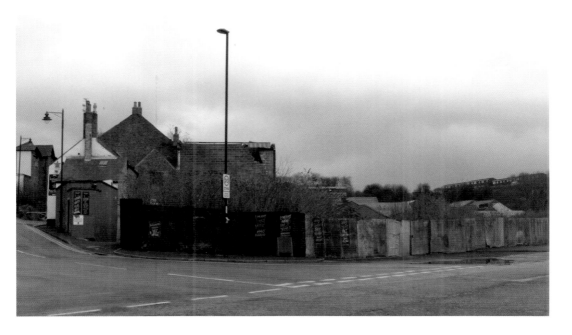

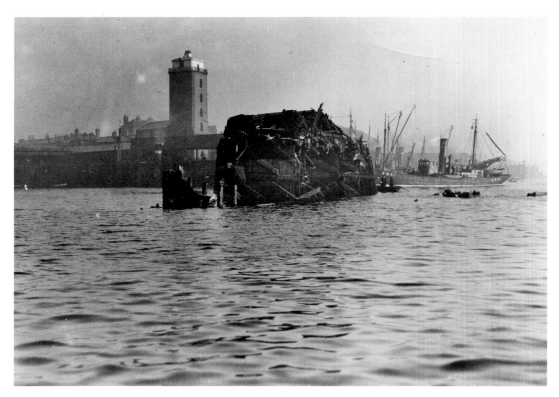

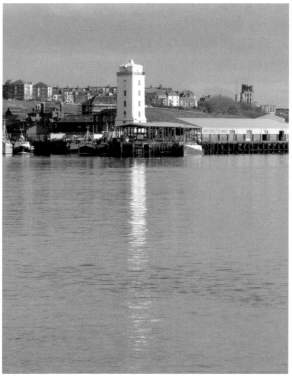

Low Light and Fish Quay
The Fish Quay jetties were badly
damaged by a collision with the
SS *Blue Star* on 22 November 1938.
The Low Light is the dominant
feature from the river in both
photographs – in the later one it is
painted white. Ruins of the priory can
be seen clearly in the background on
this bright February morning in 2013.

Fish Quay Gut
Looking towards the Old Low Lighthouse and the previous Low Light building, latterly almshouses and soon to become a heritage centre, the Fish Quay was once the hub of the fishing industry in North Shields. Now a conservation area and site for visitors, the quayside still retains its fishing heritage and has a thriving restaurant and café culture, with modern housing overlooking the river mouth. SN29 was the *C. T. Purdy*, scrapped in 1961.

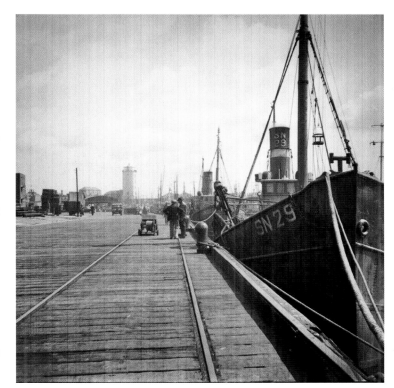

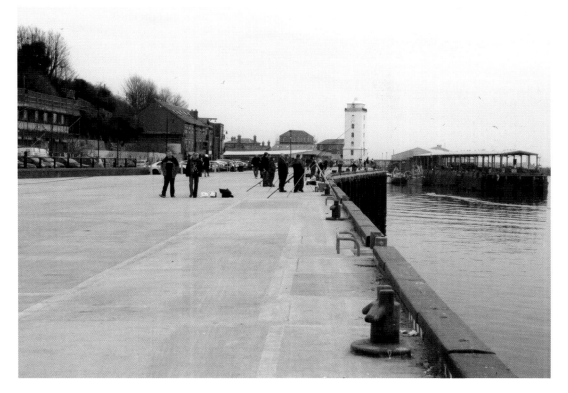

Knott's Flats

James Knott's memorial youth centre at the YMCA and Knott's Flats were built in 1939. The flats were on the site of the old Percy Square, off Tynemouth Road, and provided multistorey housing for numerous families with a view over the river and harbour mouth. A promenade now leads from the Fish Quay to Tynemouth, seen in the foreground from the river, with the distinctive white Low Light building that was once a lighthouse but is now an unusual riverside residence.

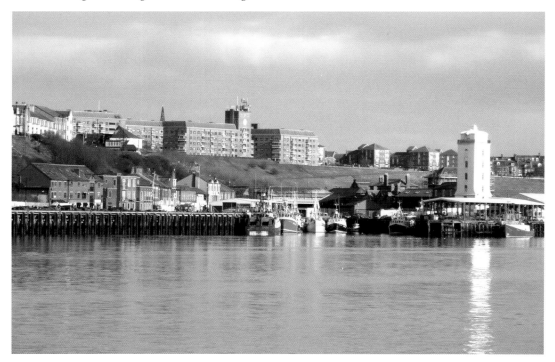

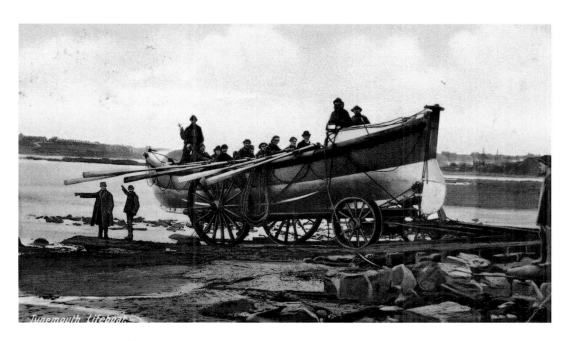

Tynemouth Lifeboat

The modern RNLI relief Severn Class lifeboat RNLB *The Duke of Kent* 17-45, built in 2005 and pictured at the Fish Quay in October 2011, is much more high-tech and streamlined than the old rowing boats used in the postcard of 1906. The current RNLI lifeboat based at the North Shields Fish Quay is the largest of the fleet – the 1995 *Spirit of Northumberland* 17-20, supported by 1963 D class inshore lifeboat D693 *Mark Noble*.

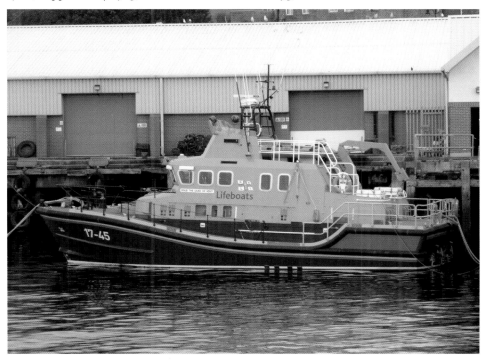

Clifford's Fort, Fish Quay

Old fish processing sheds on the Fish Quay have been converted to offices. Fishermen's Mission moved into part of Clifford's Fort, formerly the headquarters of the Tyne Electrical Engineers from their formation in 1887 until 1928 when they moved to Tynemouth Drill Hall. The fort was built to protect the Tyne during Dutch wars of 1672. Wooden Dolly pub on the top of the bank stands next to the new housing developments overlooking the river mouth.

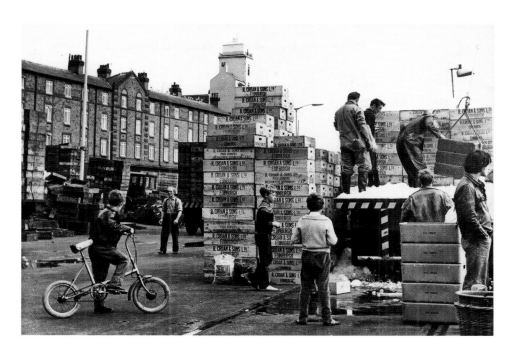

Fish Quay

The Fish Quay area is far more serene today than in this 1970 scene in which fish, packed in ice, was sold at the local fish auction ready for transportation around the country. The North East Coast Fishing Vessel Owners' Association at the time were worried at escalating costs of hired fish boxes lost among the thousands around the quayside. The modernised residential flats with garages below are now known as Quayside Court. *Top image ©North East Press*.

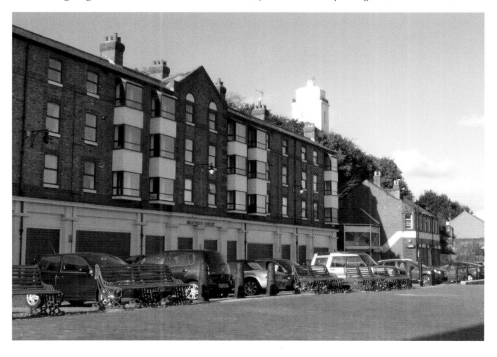

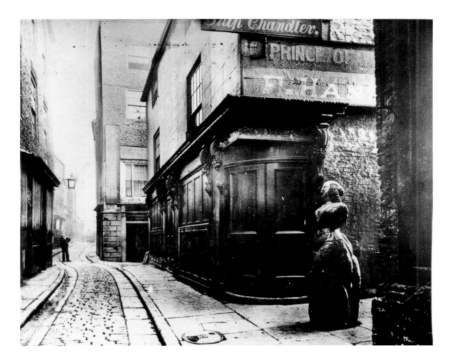

Wooden Dolly/Prince of Wales Tavern

The wooden dolly – No. 3 – standing outside the Prince of Wales Tavern on Liddell Street was once a pretty ship's figurehead, but was disfigured over time when visiting sailors and fishermen took a sliver home as a good luck charm and memento of North Shields port. Frank Hanlon, whose name is above the door, was licensee in 1891. The current dolly, sculpted from a single block of oak weighing 1½ tons, was the sixth replacement in 1995.

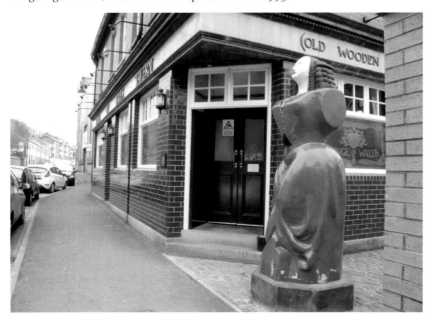

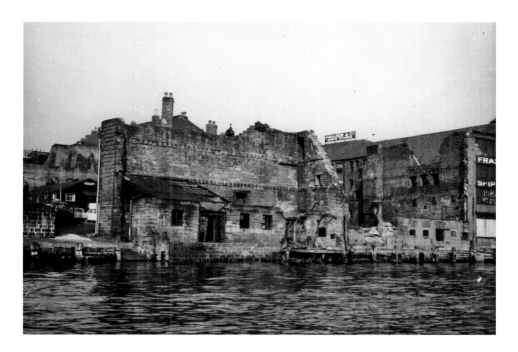

New Quay from the River

The smart new house looking out over the river was part of the derelict Brown's biscuit factory in front of the ruins of St Peter's church beside Frazer's Ship Stores warehouses in September 1961. Both views from the river show one of the 'spires' on the ends of the roof of the Porthole public house, formerly the Golden Fleece. The 'hut' in the background belonged to the British Sailors' Society.

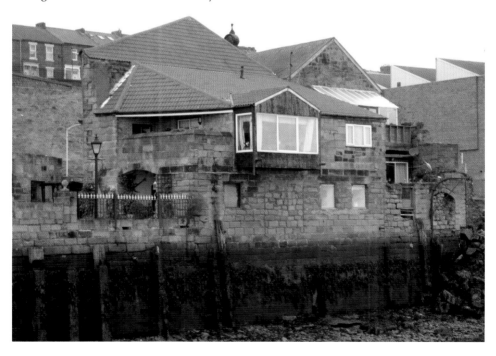

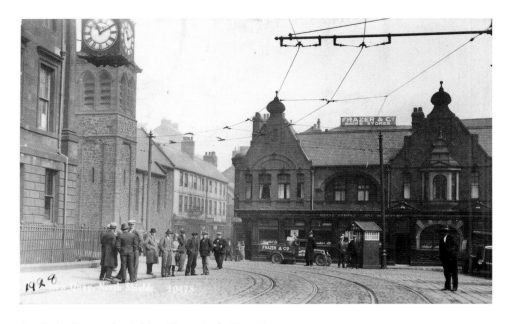

Porthole, Formerly Golden Fleece Pub, New Quay

The Tyne Sailors' Home clock on the corner of the Board of Trade Building faces St Peter's church, built in the 1860s and demolished 1937. The first baptism was of William Hubert Percy Hicks on 1 September 1864, followed by the first marriage on 6 September of Thomas Hindmarsh, butcher, and Elizabeth Mary Fleming. The Golden Fleece public house at No. 11 New Quay was owned by Deuchar Ltd and managed in 1928 by Archibald Campbell Noble. It became the Porthole around 1985/86.

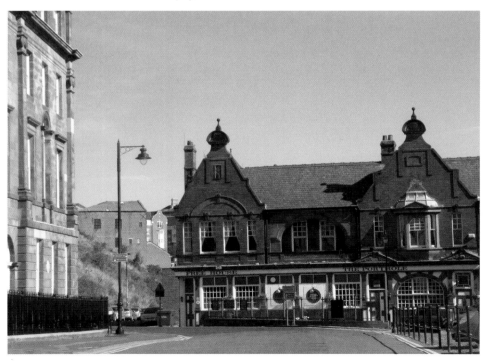

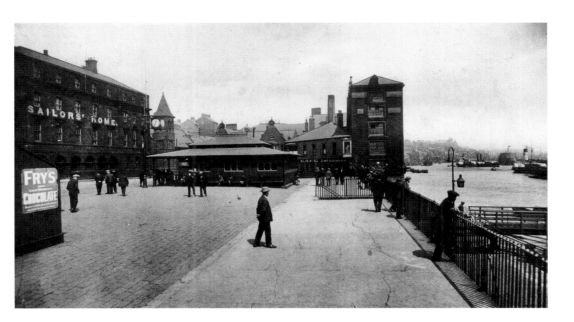

New Quay, Fish Quay

Tyne Sailors' Home was converted into luxury flats and the iconic clock removed. St Peter's church tower stood on the opposite corner from 1860 to 1937. The Porthole pub, originally the Golden Fleece, is behind the Mercantile Marine Office seamen's waiting room, now a car park. The house on the right was Lockhart's Cocoa Rooms and the tall building housing Peter Brown's 'Krisplins' biscuit factory suffered damage by fire in January 1932 and another in April 1932 that destroyed it completely.

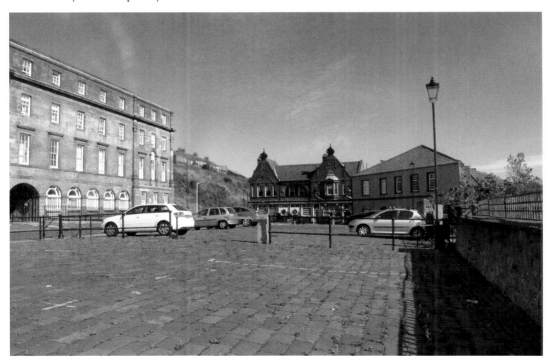

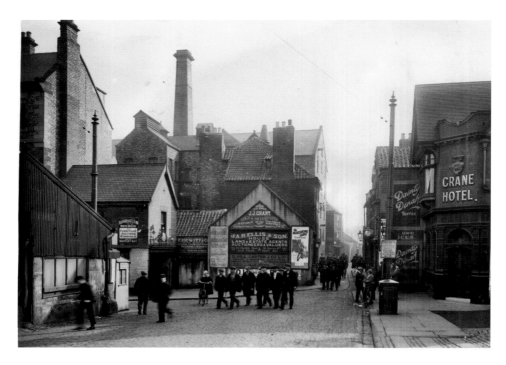

Crane Hotel & Ferry Entrance, New Quay

The shape of Swinburne & Co., then Newcastle Breweries, Crane House Vaults, can clearly be seen on the right, and is the only surviving building on that side of Duke Street. On the opposite side of the street in the centre is the large imposing building of the former brewery, with the entrance to the ferry landing stage on the left labelled Ferry Mews. The buildings beyond the pub on the right have been demolished to make way for the bus terminus.

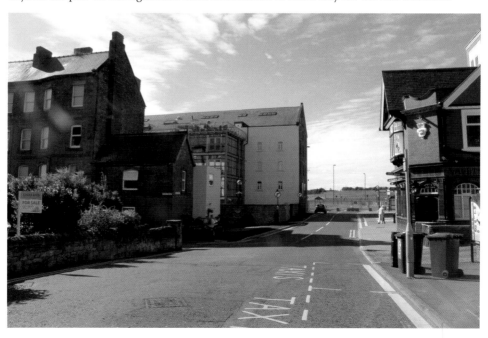

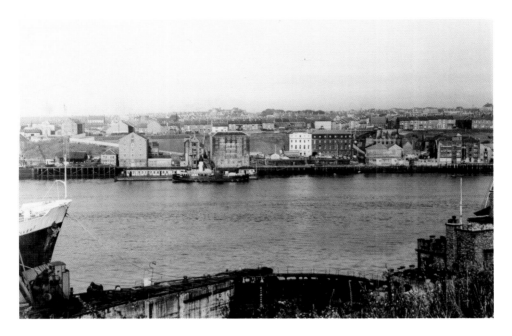

Ferry Landing

In this view of North Shields New Quay from the South Shields side of the River Tyne, the busy riverside where Smith's Dock once stood, surrounded by white stone walls, has now been almost cleared to make way for new housing. The old vehicle ferry, unloading in 1946, is at the landing stage in September 1965. It is now passenger only, with a smart new bridge and waiting room area, painted blue to match the new ferry, see here in August 2012.

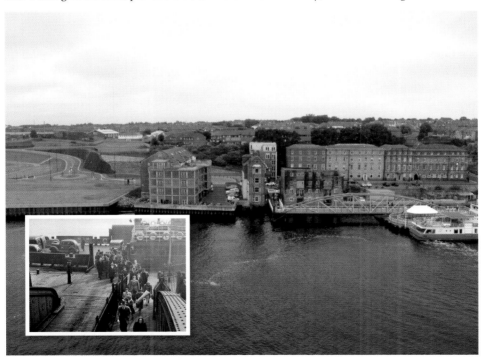

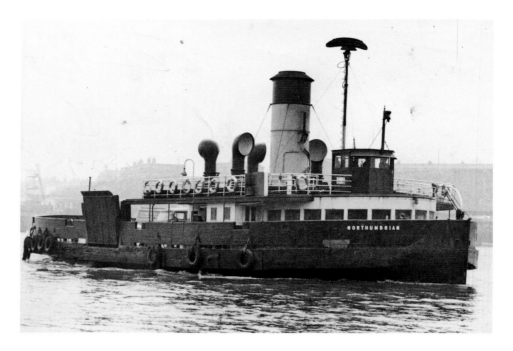

Ferry Crossing the Tyne

Northumbrian ferry taking passengers and vehicles across the river in January 1969 and just before the start of redevelopment of Smith's Dock area in the 'Indian summer' weather of October 2011, the modern *Spirit of the Tyne* passenger ferry travelling from South Shields to North Shields in the foreground. The large building in the background is the local listed Wolsington House pub, built by local architect John Spencer in 1902. *Top image ©North East Press.*

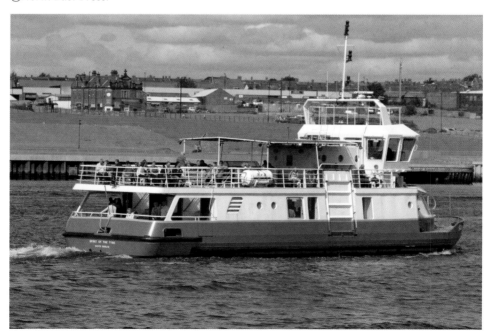

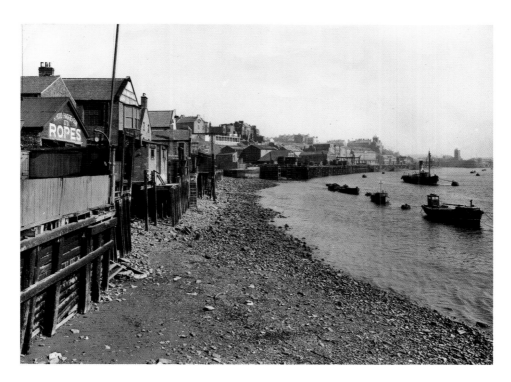

River Tyne

The hazy view on a rainy February day in 2013 shows how the river banks have changed over time. The only landmarks still there are the High and Low Lighthouses in the distance and the tip of the Stag Line building above the trendy newly refurbished dwellings overlooking the river in front. Dolphin Quays flats are next to the old Haddock Shop in the centre. The ropery on the left, seen here in April 1951, was owned by R. Hood Haggie.

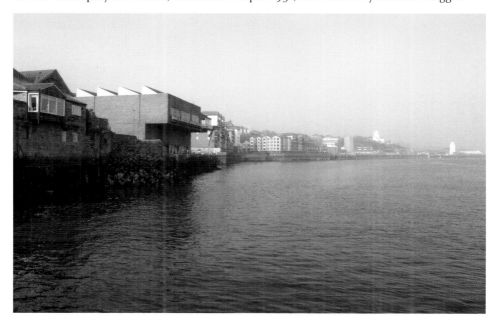

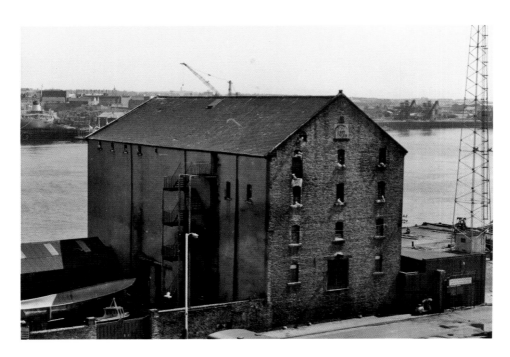

Brewery Bond Warehouse, New Quay

The square plaque at the top of this building in Duke Street dates it at 1871. From trade directories 1871–86, Ferry House and the butcher's were next to Henry Harrison, bonded store dealer, and William Henry Allison, brewer at Grindstone Quay. Sea birds took every opportunity to nest in the window areas of the building. The boatyard is now a car park for the modern luxury flats overlooking the river, with glass exterior spaces replacing the former fire escape.

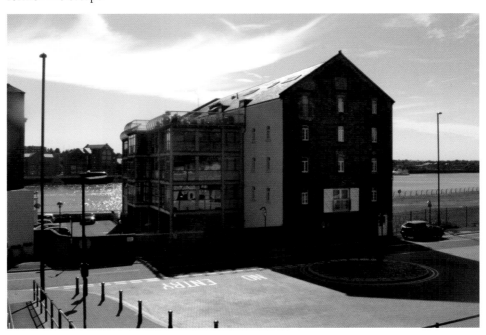

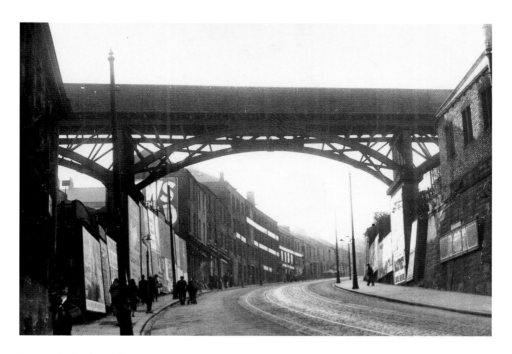

Borough Bank Bridge

Under the bridge at Borough Bank on the way up from the quayside and the ferry landing was a perfect place to advertise to passers-by in March 1933. Most of the buildings, other than the residential ones at the top and bottom, have been removed and the bridge has been uncovered and restored. By April 2012 motorists took advantage of the long road for car parking and not so many people are keen to walk up and down the steep bank.

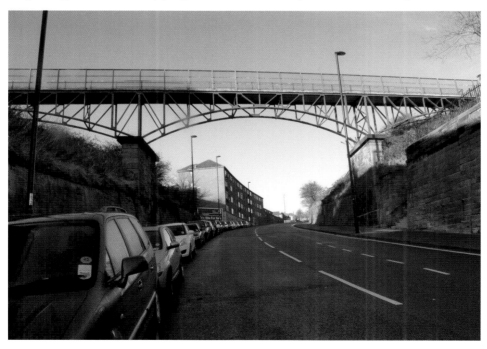

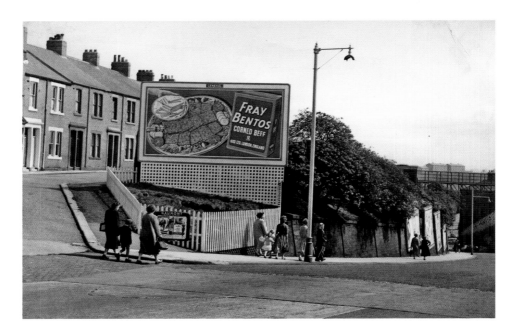

Borough Bank

In light summer coats, heading down Borough Bank towards the ferry landing under the bridge in August 1957, these people may be going to South Shields market. An advert below the Fray Bentos poster on the white picket fence is for the Gaumont Cinema showing the latest film releases: *The Garment Jungle* with Lee J. Cobb and *The Burglar* starring Dan Duryea and Jayne Mansfield. The fence has been taken down and the poster advert is now for television movies.

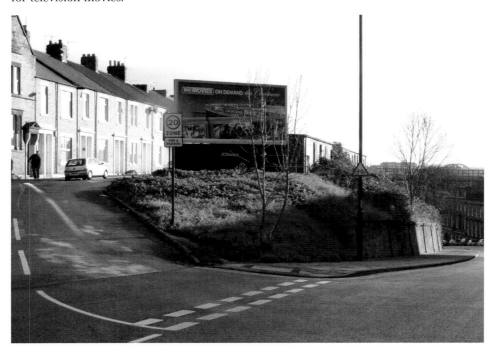

Sibthorpe Street

The Tyne Steam Packet Provident Society was established in 1853 to raise relief funds for members whose families had found hardship through sickness, unemployment, confinement and bereavement. It was registered as a trade union in 1871, with the original headquarters on New Quay, before moving to Sibthorpe Street, on the corner with Waldo Street just off Borough Bank, in 1897. It became the North East Coast Tugboatmen & Fishermen's Association in 1924, with branches in Aberdeen, Middlesbrough and Hartlepool.

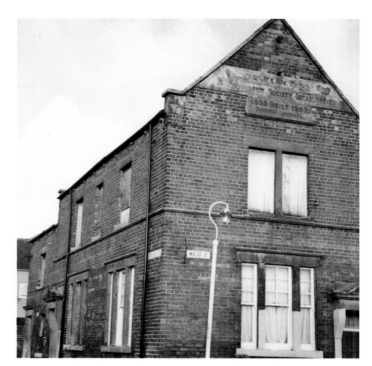

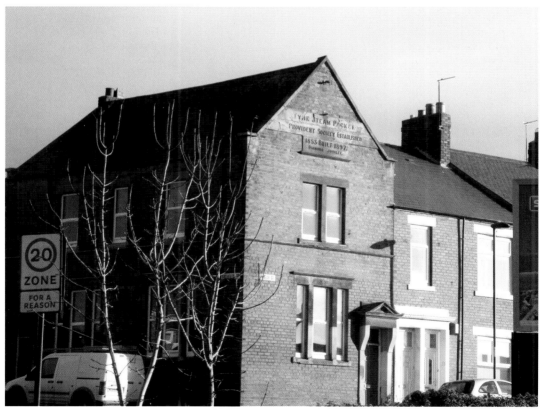

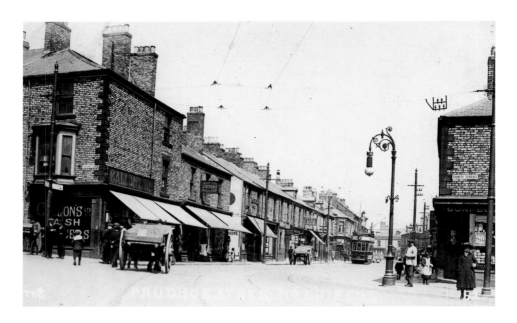

Prudhoe Street

Gallon's Cash Grocers is listed in trade directories from 1909–13 as being on the corner of Prudhoe Terrace, Coach Lane, now painted white. J. W. Taws, draper, is next door and listed until 1940. In 1958 the street from Trinity Terrace was shops with flats above, now replaced with housing. A tram is passing the Theatre Royal, formerly leased by Arthur Jefferson, father of Stan Laurel. The North East Rubber Company was opposite the Ballarat Hotel in the distance.

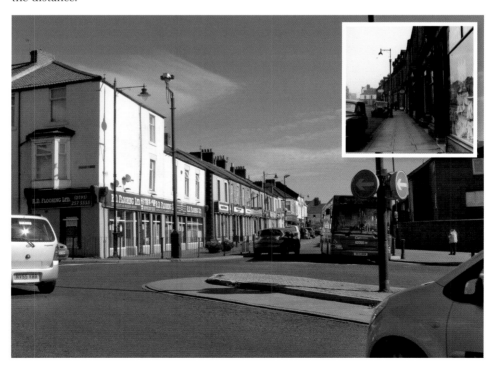

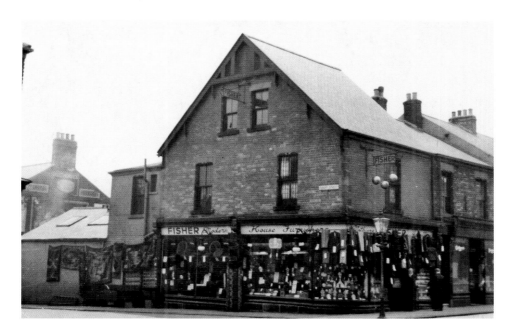

Howdon Road

The Tynemouth Disabled & Ex-Servicemen's Club & Institute is at No. 61 Howdon Road on the corner with Thrift Street and is known locally as the 'pan shop club'. The building was occupied by Fisher's pawnbrokers from 1901 and the colloquial usage of the term 'pawn shop' as 'pa'n shop' has stuck. Here in 1940 Sunday best suits are hung outside for the week until they are 'bought back' for the following weekend.

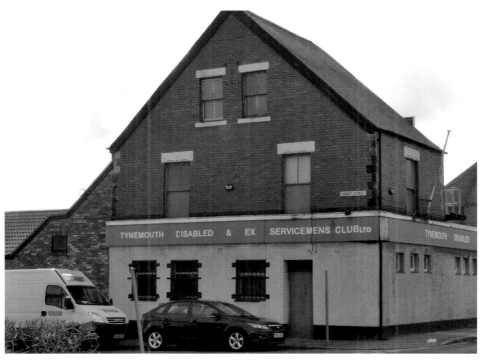

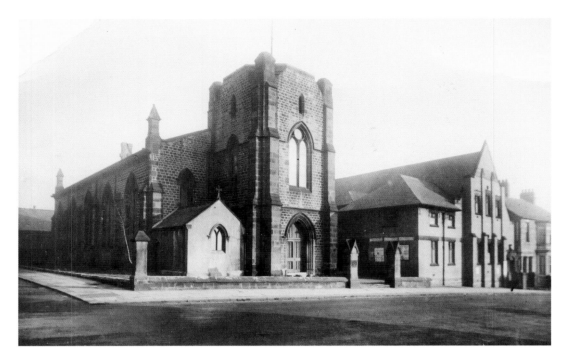

Trinity Terrace, Coach Lane

Trinity Close care home stands on the site of Holy Trinity church at the bottom of Coach Lane. The foundation stone was laid in September 1834 by Lord Prudhoe. The church was consecrated in October 1836 and became the parish of the Most Holy Trinity in July 1868. It held its last service in March 1982. The Berwick Arms Inn was on the opposite corner, an ornate tiled Victorian building at No. 1 Trinity Street, briefly called Trinity's, now closed.

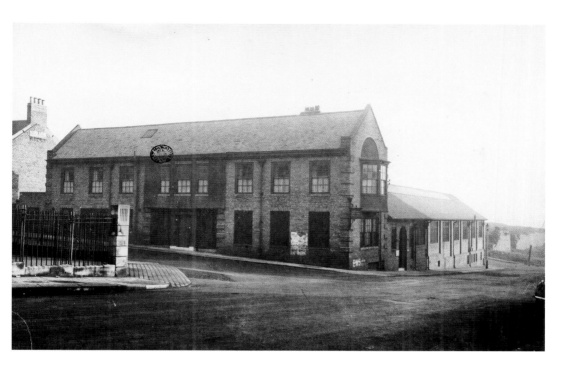

Addison Street

New housing is behind the space left by the demolition of the main office buildings belonging to Smith's Dock Co. Ltd, engineers, boiler and ship repairers, and pontoons and graving dock owners at Coach Lane in 1946. These offices were closed in 1963 when the new four-storey office block at the Smith's Dockyard was opened by chairman Sir Eustace Smith and staff from all three dock offices merged.

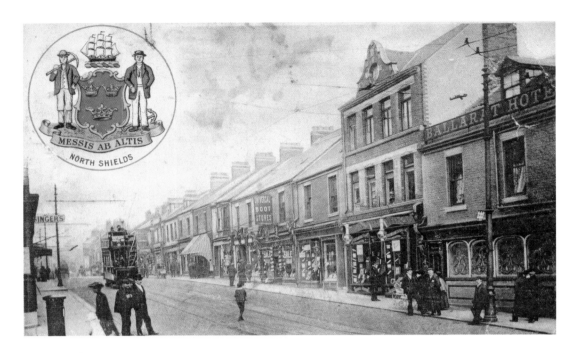

Saville Street West

This card, stamped with the Tynemouth County Borough coat of arms, was sent to Harry Chambers at Rothbury Camp when he was there with 2nd Tynemouth Boys Brigade in 1906. The Ballarat Hotel was named for the Australian goldfield where the first publican Thomas John Dodds once lived. The earliest mention of the Ballarat in trade directories is in 1871, although the deeds to the hotel suggest that it was built on land bought in 1855.

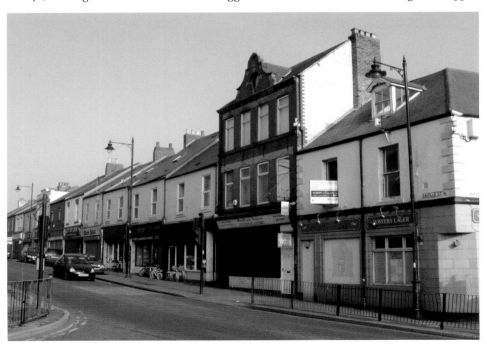

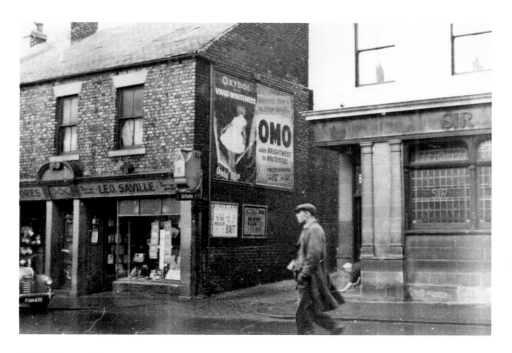

Saville Street West

Behind this gent, out for a morning stroll in January 1955, is a lady scrubbing the steps of Sir Colin Campbell pub, currently Prestige House furnishings. On the opposite side of the lane is Leo Saville's Stores, now Unwind hairdresser's, at the Borough Road end of Saville Street West. Adverts on the side of the shop are for Omo and Oxydol detergents, with a smaller Boro' Cinema flyer for *The Mad Magician* starring Vincent Price and Eva Gabor, released in 1954.

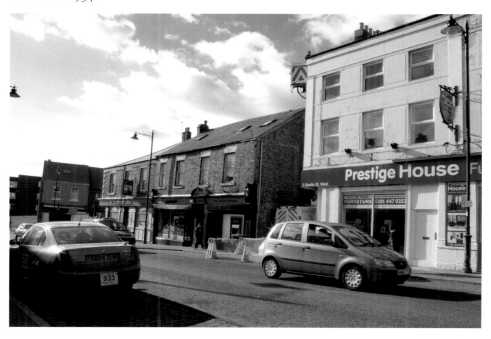

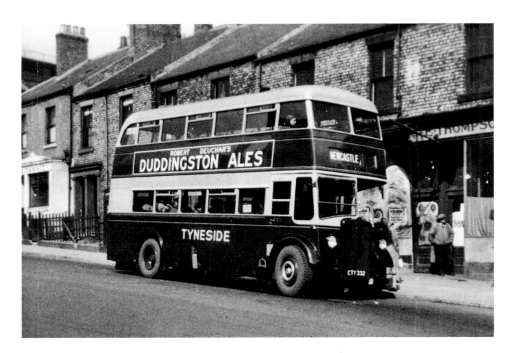

Borough Road

The 1948 Leyland green bus CTY332 used to take workers to the shipyards along the riverside via Howdon, Wallsend and Byker to Newcastle. This bus stop was at the bottom of Borough Road in the 1960s, a little further down the street from Walkers department store, outside E. Thompson's hairdressing salon. The white frontage of Britannic Assurance Offices is just beyond the bus, and Rank Taxis had an office here beside the fish and chip shop. *Top image ©North East Press.*

Borough Road

Walkers 'The House of Quality' was a department store offering purchases in instalments, making school uniform and furnishings easier to afford. The store used a cash carrier system in which the payment was sent to the office via a series of pneumatic tubes and change was returned in another capsule; a similar system is still used in the Beamish Co-op store. Some of it is boarded up and the Victoria pub beyond is now Pantrini's fish and chip shop.

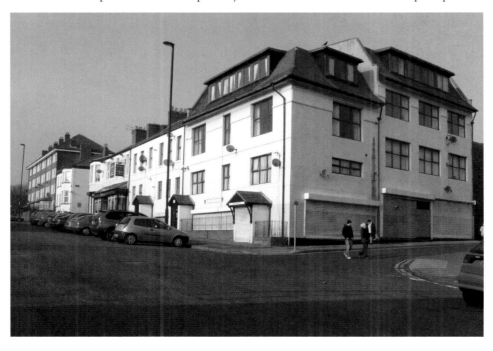

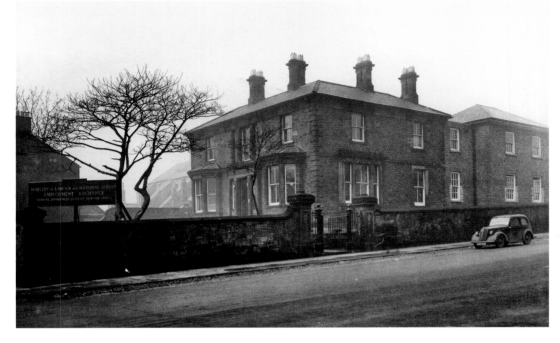

Employment Exchange, Borough Road

In 1946, the old dole office on Borough Road, opposite Walkers Ltd, was at the opposite corner of William Street West to Alexander Scott Park. Previously Custom House and Custom House (Waterguard), the Ministry of Labour Employment Exchange offices were in this formidable building with a women's department at No. 97B Bedford Street. It is now Amron House, offices of commercial property and IT/software consultants.

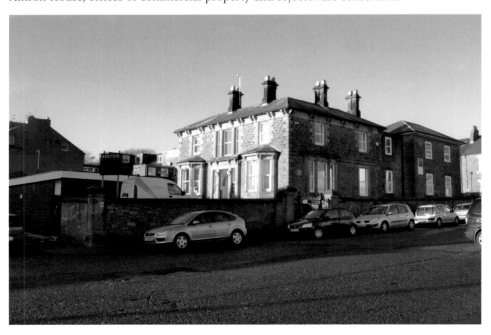

Borough Road

The top of Borough Road leading from the railway station was in a bit of a sorry state when Compulsory Purchase Orders were served during post-war slum clearance programmes, possibly as late as the early 1960s. The tenement housing has been replaced by Morgan House. Pantrini's award-winning family fish and chip restaurant and takeaway is now in the old Victoria public house, which can just be seen on the opposite corner to this block.

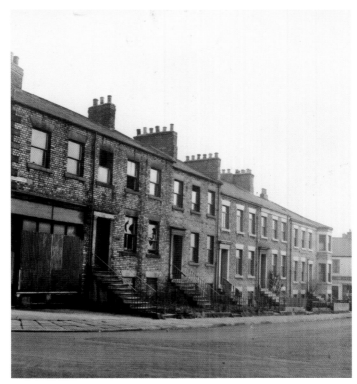

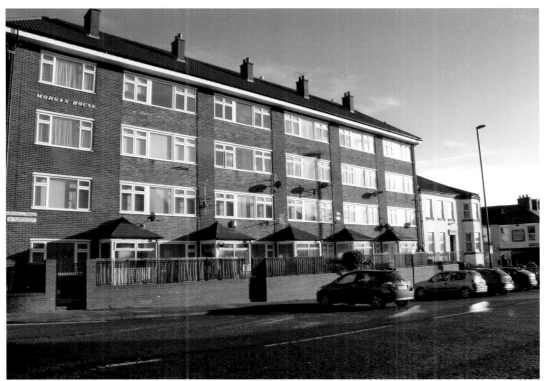

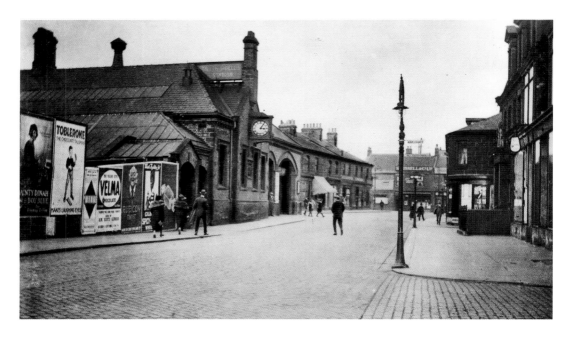

Railway Station and Bedford Street

Looking beyond North Shields railway station into Bedford Street is S. Russell & Co., fruiterer, listed in trade directories from 1922 to 1932, which had premises next to the White Hart public house with North Eastern Railway stables in between. The White Hart, opened pre-1864, was renamed the Cask & Stillage in March 1993 and planning permission was granted to turn it into an amusement arcade in 2001. Boots the chemist stands at the entrance to the Beacon Centre.

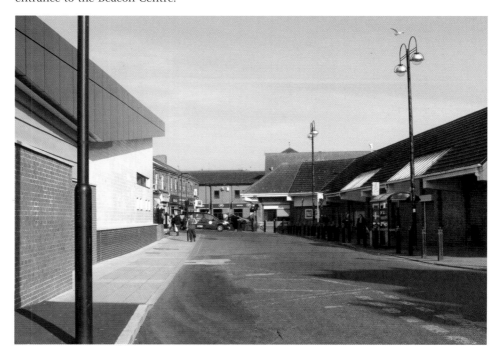

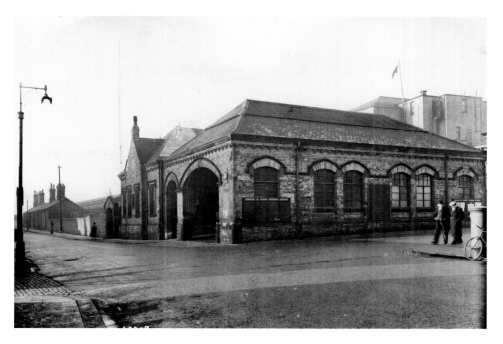

North Shields Station and Railway Hotel, Nile Street

Looking up Nile Street, the newly refurbished metro station entrance is dominated by the back of the imposing building of the former Gaumont Cinema, previously Princes Theatre opened in 1929 by Dixon Scott, who died in 2012. Noble's Amusements took over the Railway Hotel in 1980. A hotel was built at the railway terminus in 1842, before the track was continued to Tynemouth.

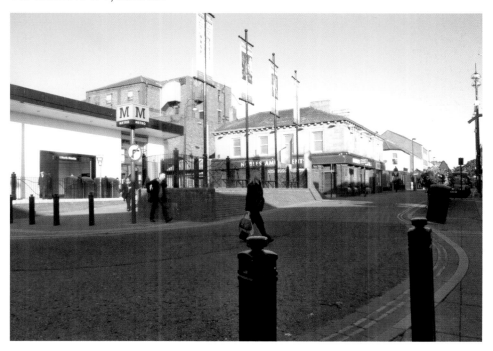

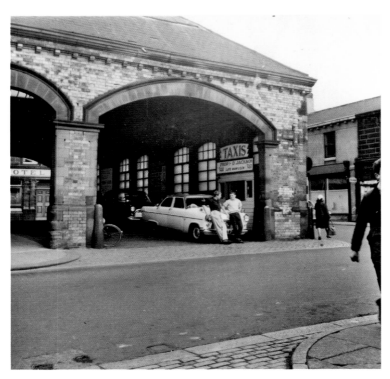

Railway Station

Looking from Railway Street towards the Railway Hotel under the station entrance archways was the taxi rank – at this time D. Jackson, formerly Maw & Son. The new frontage of the metro station in 2012 gives a view towards Nile Street showing Hoult's pork butcher's and Nobles Amusements in the former Railway Hotel.

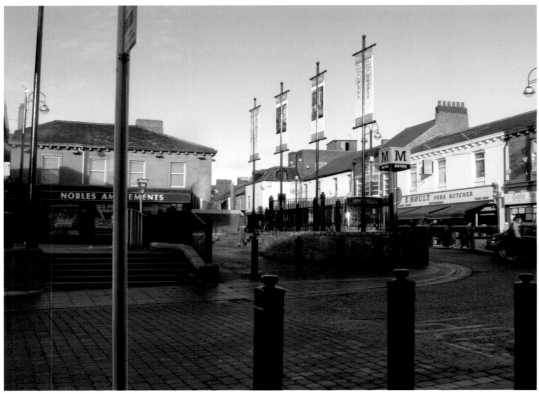

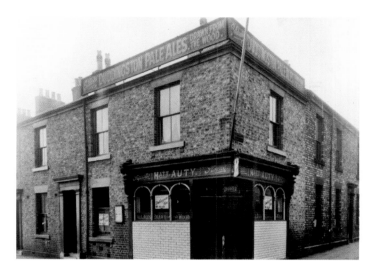

Aquatic Arms

On the corner of William Street and Rudyerd Street the Aquatic Arms public house, built before 1864, was owned by Matthew Auty from 1914 to 1940 and extended into the next building in around 1931. Licensee Nora Rennie is listed from 1946 to 1972. Bishop's haberdashery store was there for many years, next door to Jobes' radio and television repair shop. The Rudyerd Street entrance is used for The Phone Shop and the William Street doorway has been blocked up.

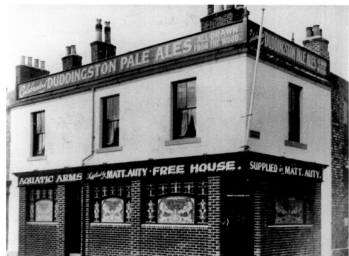

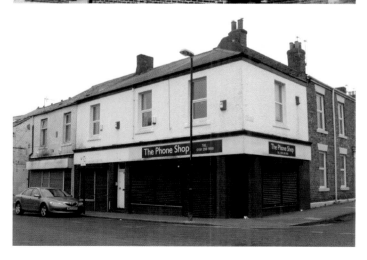

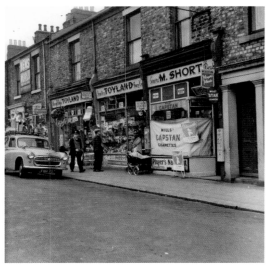
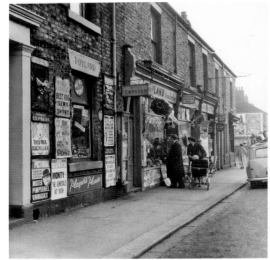

Toyland, Rudyerd Street

Dolls' prams, scooters and bicycles hanging outside Toyland in 1958 leave no doubt that this trusting proprietor wanted to advertise his double-fronted toyshop. M. Short next door has a sun-break in the window of the tobacconist's to protect his wares. The postman in his smart uniform and hat is passing by. As a contrast, the new buildings forming the back of the Co-op extend along to this corner, with a carpet shop tucked in behind the bus stops.

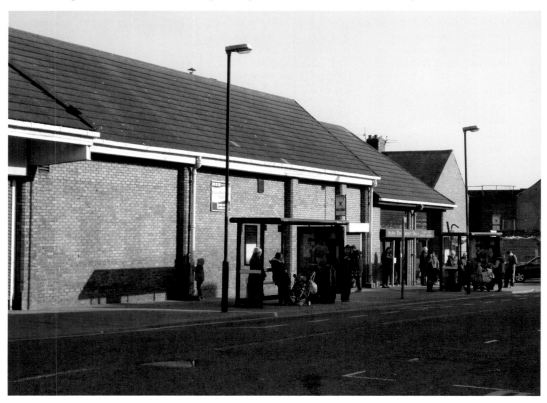

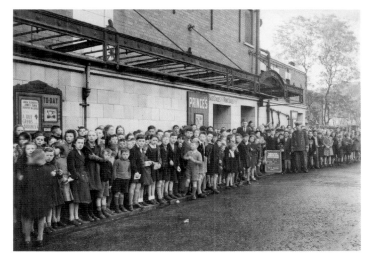

Prince's Cinema
Gaumont British Junior Club notice board announces the programme awaited by this queue of children outside the Prince's Cinema in 1946 – *Miss Fix It*, *Stranger than Fiction* and *Pirate Treasure* – with the commissionaire keeping them in line. The Junior Club formed in 1944. *A Tree Grows in Brooklyn*, released in 1945 starring Joan Blondell, from the 1943 novel by Betty Smith, was showing for adults. The cinema was refurbished in 1950 but closed in 1982, reopening later as a bingo hall.

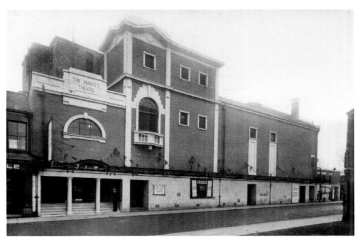

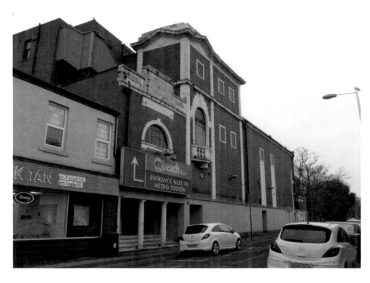

41

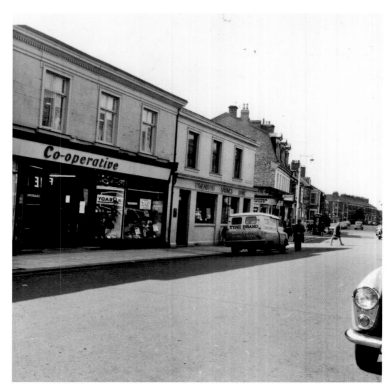

Railway Street
On the opposite side of the street to the row of shops leading to the station was the Co-operative store, now much modernised and taking up the whole of the corner of Bedford Street and Railway Terrace, incorporating Mr Wood's Café at this end and the extension to the store. A Tyne Brand van is parked outside the Tynemouth Savings Bank and the telephone box is on the corner of Rudyerd Street in the 1960s.

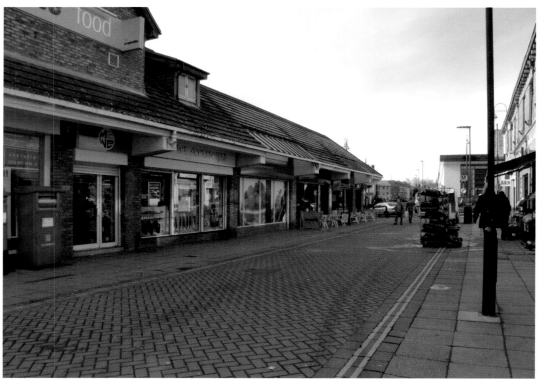

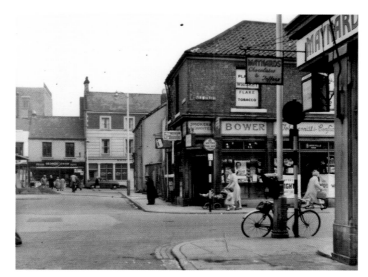

Russell Street

Looking past the newsagent's on the corner of Nile Street towards Bedford Street in November 1958 is the White Hart public house, now a Salvation Army charity shop, and George Swan's pram shop, which is now Poundstretcher. Opposite Maynard's, Bower was on the corner of Nile Street from 1940 with Bolton's menswear next door from 1930s. The slim Telegraph Inn, with the squared top, was listed in trade directories from 1882, as was Elwes draper's, now Hoult's butcher's shop.

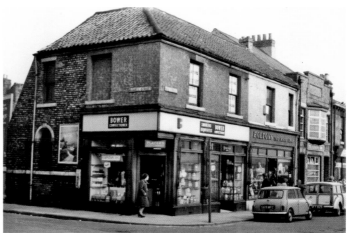

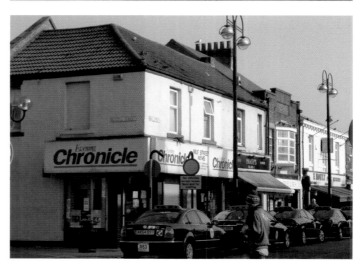

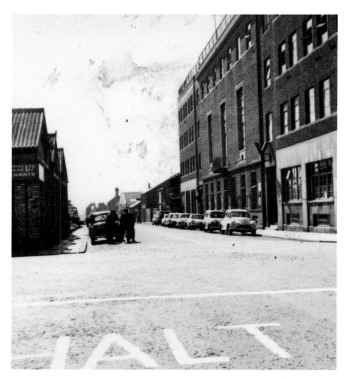

The Back of the YMCA Building, Corner of West Percy Street and Church Way Tynemouth Young Men's Christian Association campaigned for new headquarters from a house in Camden Street. They raised £5,000 over ten days in 1913, when a huge screen was erected outside Tasker Hall, Howard Street, with a drawing of the proposed Bedford Street frontage. Each day fundraisers painted on how much of the building could be completed with the amounts pledged. Young's potato merchants was on the site of the current HSBC Bank and Church Way extended down to the banktop.

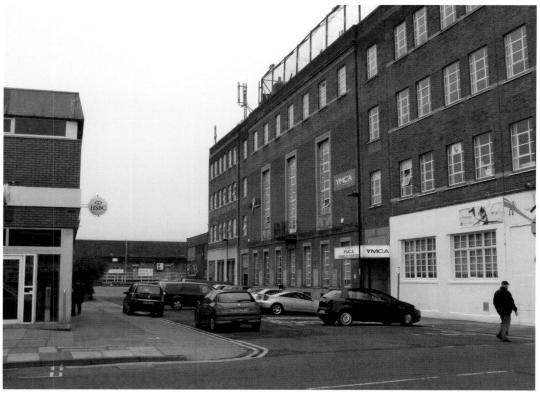

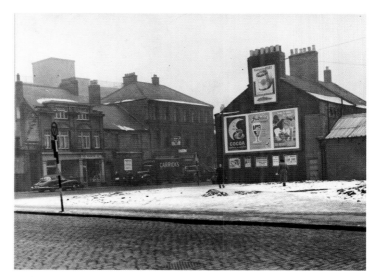

Bedford Street
Looking from West Percy Street across waste ground in 1954 where Lloyds TSB now stands, Carrick's wagon is in front of their bakery below the YMCA Boys' Club. Harts is just off the corner. A poster opportunity on the side of the remaining buildings advertises current cinema showings including *Second Chance*, a 1953 film starring Linda Darnell, Jack Pallance and Robert Mitchum, at the Rex. In 1960 Atkinson fruiterers had a branch on the corner of Nile Street.

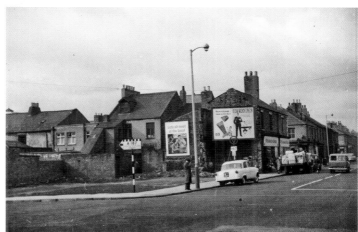

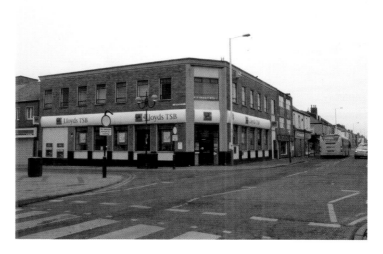

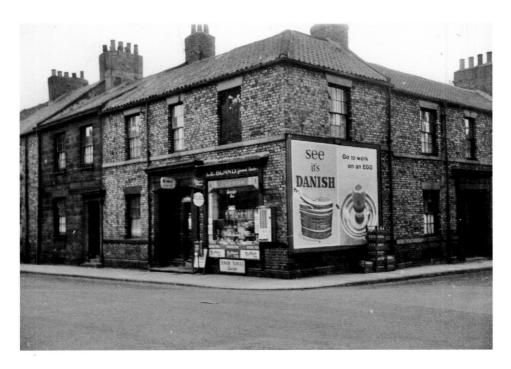

West Percy Street

Gills Fish Bar on the corner of Sidney Street and West Percy Street, opposite the Terminus Club, was Bland's general dealer in 1960, with the milk crates stacked up outside ready for collection under advertisements for Danish bacon and the 'Go to work on an egg' campaign.

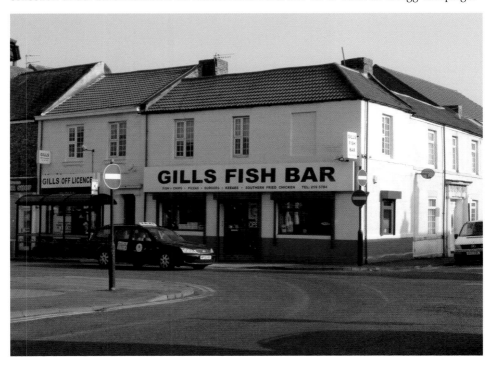

Widdrington Terrace, West Percy Street
Taken in 1962 this section of West Percy Street known as Widdrington Terrace shows Cowey glass merchants, which is still there. Tom Swan's, with the builder's yard at the rear, moved into larger premises on Tynemouth Road at the top of Tanner's Bank, and the building now belongs to Maxwells DIY store. The rest of the terrace is residential.

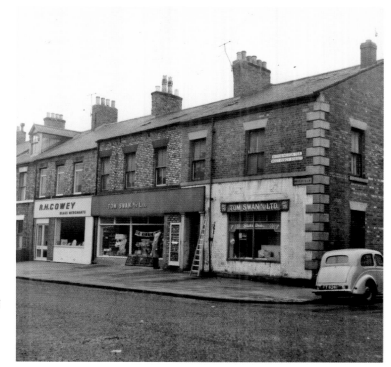

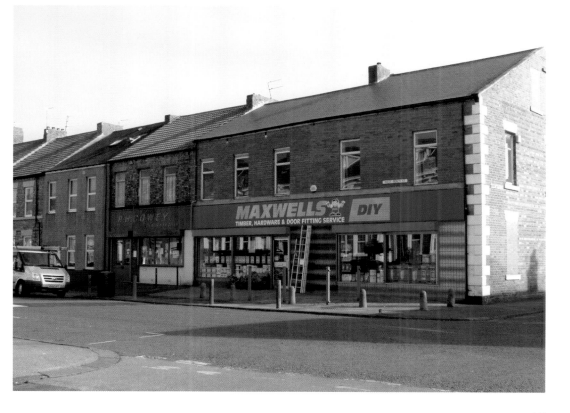

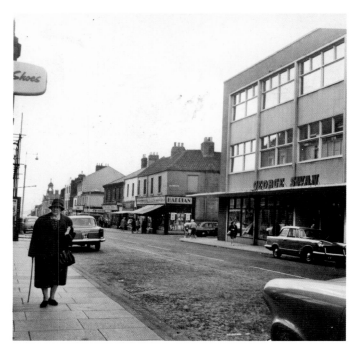

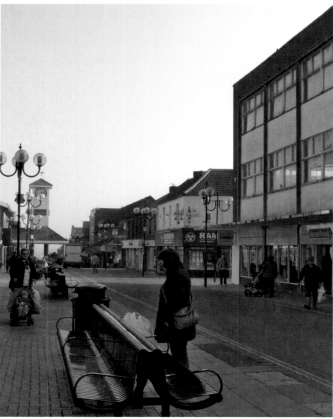

Bedford Street
George Swan senior, a
blacksmith, moved on to
selling bicycles. Joined by his
son George, they opened a
cycle store in Railway Street
and later branched into radio
and electrics. Their Bedford
Street department store
opened in 1959 and was
taken over by Shepherd's of
Gateshead in 1965 and then
became Jopling's. It is now
Heron Foods, which moved
from the top of the street
into larger premises vacated
by a sports goods store at the
end of 2012.

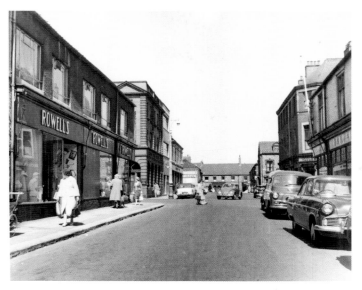
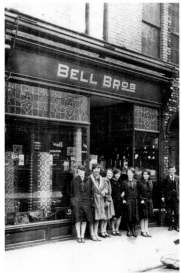

Bell Brothers Stores, Bedford Street & Wellington Street

Bell Bros stores at No. 95 Bedford Street stretched right back to Little Bedford Street along Wellington Street opposite Rowell's, which may explain why reflections of the Lambton Castle Inn signs can be seen backwards in the windows behind the shop girls. Originally opened in 1921 by Jimmy Anderson, the store was bombed out during the 1941 air raids and reopened after extension and modernisation in 1962. It is now one of the few remaining branches of Peacocks clothing stores.

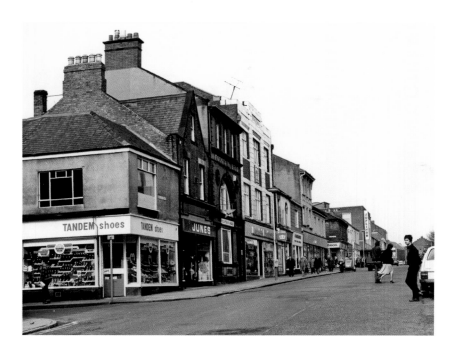

Bedford Street

McDonald's restaurant is a new build on the corner of Bedford and Russell Streets, the former site of Rowell's gowns and Hogg's draper's, opposite Bell Bros stores. The large white building was the original Bainbridge's Priory House furnishers, which moved to Newcastle, but the name Priory House can still be seen above Iceland frozen foods store. The Phoenix Hotel (1827), then Bedford Hotel (1865), became the Fountain Head in 1891. It closed in 1980, and was next door to Priory House.

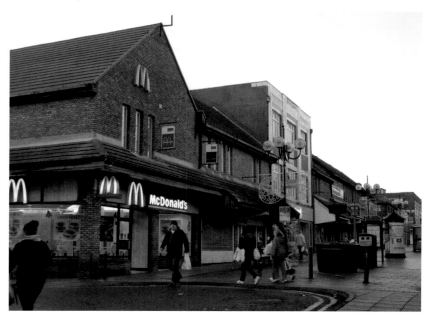

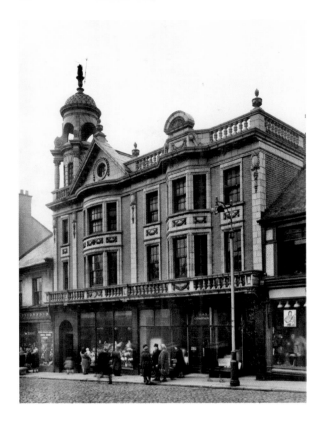

Gas Showroom, Bedford Street
The beautifully ornate building,
which housed the gas showroom
seen above in 1946, is now home to
the Pow Burn pub. Tynemouth Gas
Company is listed at No. 97 Bedford
Street from 1886 in trade directories
and became Newcastle upon Tyne
& Gateshead Gas Company in
1928. Prior to that, in 1871 it was
Tynemouth Club. Bell Bros tailors
were next door from 1928, and
Gladston's ironmongers moved in to
No. 99 in 1930 and are still trading.

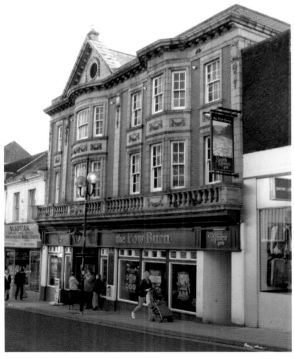

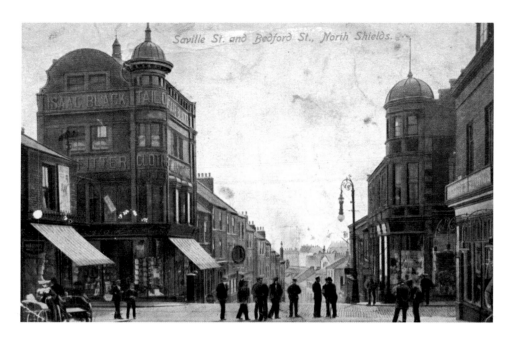

Bedford Street

At the bottom of Bedford Street was Maynards sweetshop, its entrance on Saville Street. This is where Home Bargains Store now is, in the former Littlewood's Stores. Opposite is the Direct Raincoat Company's four-storey premises, formerly Isaac Black's tailor's and outfitter's shop (*inset*, 1904), with a newsagent's shop on the ground floor. The dome has been removed from the building on the other side of the road.

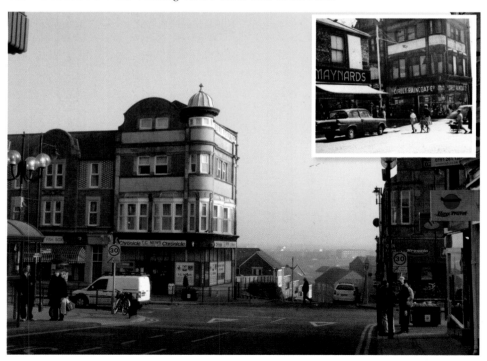

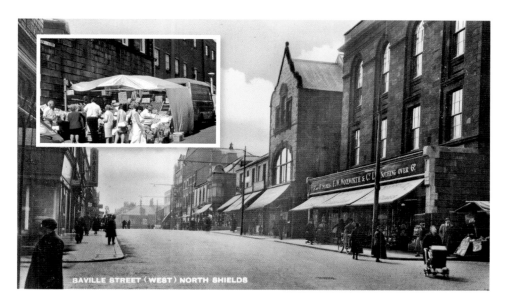

SAVILLE STREET (WEST) NORTH SHIELDS

Saville Street West & Little Bedford Street Corner

The wide range of building styles in Saville Street West creates an interesting skyline. F. W. Woolworth's stores were in the former Primitive Methodist chapel, with one storey removed, on the corner until January 2009, with Smith Bros' fruit and vegetable barrow in Little Bedford Street outside until 1990s. Kendra Furnishers' three-storey building next door was originally Gregg's Cocoa Rooms. Home & Colonial Stores was in the Oxfam shop with the flat roof and G. K. Lee's clothing store was opposite. *Inset photograph ©A. H. Beautyman.*

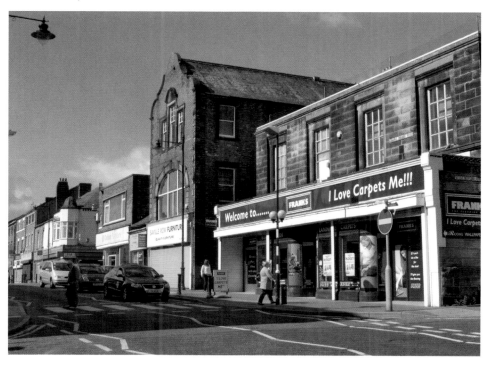

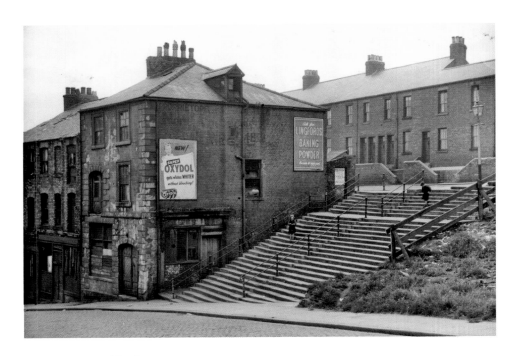

Tiger Stairs, Bedford Street

Brother and sister George and Rene Vella are playing on the stairs leading up towards Ropery Bank at the end of Little Bedford Street in this iconic view from 1939. The Tiger Stairs, at the bottom of Bedford Street, facing Union Street, were named for the Tiger Inn public house on the south side, which was there from 1831 to the late 1920s. The restored staircase is now topped by the smart new houses of Rudyerd Court.

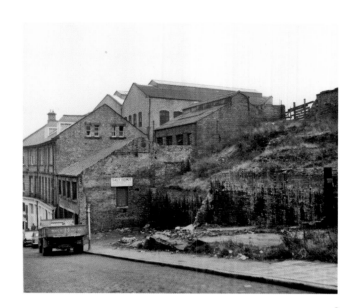

Lower Bedford Street
Between the Tiger Stairs and Grieves' Stairs was the Salt Depot, seen in 1962 at the end of the buildings when it was yet to be demolished. The depot has gone but the roofline can still be seen against the top end of Grieves' building with the unusually curved frontage at the foot of Little Bedford Street, latterly used as George Bilclough's Plumbing & Heating Works, and the stairs have been exposed between the buildings.

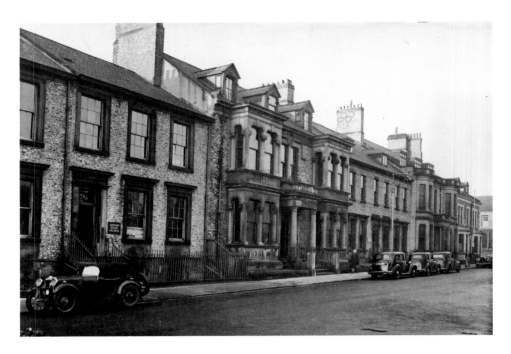

Northumberland Square

The west side of the square, seen in 1946, was originally residences for the well-off in the town, with access to the locked 'garden' in the centre. The plaque on the left-hand building advertises the Assistance Board Area Office. Modern social housing provided in 2013 kept the external structures of the remaining properties on this side after council workers moved out. The bottom part of the street was demolished in the creation of the Beacon Shopping Centre and library.

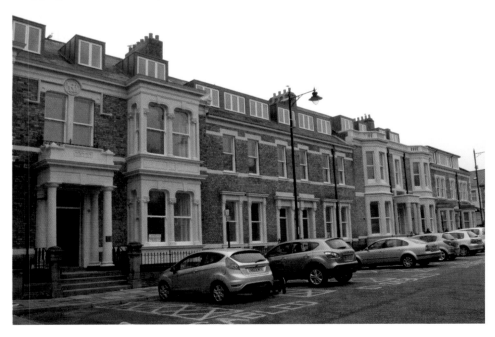

Northumberland Square

The bus company enquiry office and Rotary Pavillion is where North Shields Library, officially opened on 12 February 1975 and refurbished 2012/13, now stands. The square was once open to traffic all around, but the Camden Street side was closed off when the library, and a few years later the Beacon Shopping Centre, were built.

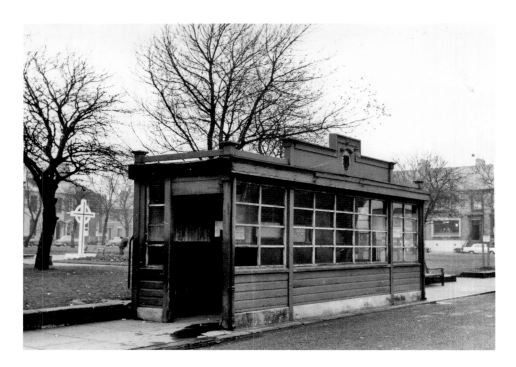

Northumberland Square

The bus shelters in 1957 stood around Northumberland Square, then with no railings as they had been dismantled for wartime scrap metal. The cenotaph in the background and the bare trees depict a November day. A wintery 2000 picture of the square shows the east side leading up towards Albion Road and down to Norfolk Street. Northumberland Square was once a private garden for the use of the residents of the large houses, but is now a public park area.

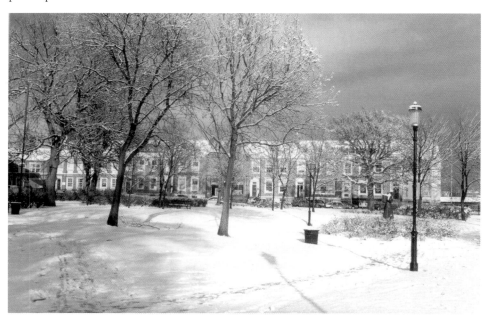

Northumberland Square

Camden Street once went right down to the bank top through the centre of North Shields but is now cut off by the Beacon Shopping Centre next to the library, which is on the site of the former bus station. The bottom of Northumberland Square was shortened to make the entrance, and the demolition of St Andrew's church, latterly used as a furniture showroom, made way for Barclay's Bank in the shopping precinct.

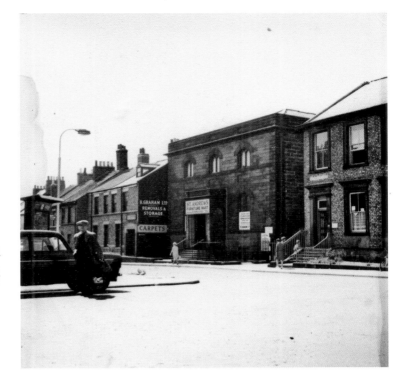

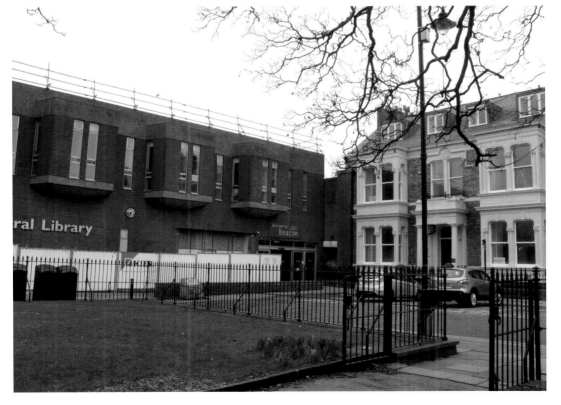

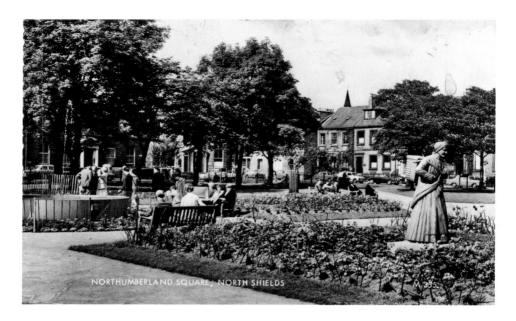

NORTHUMBERLAND SQUARE, NORTH SHIELDS

Northumberland Square

The fifth wooden dolly was unveiled by Thompson of Kilburn in 1958, on Miss Spence's 100th birthday and based on her original design, with two mice hidden around her skirts. The fountain, donated in 1959 by Richard Irvin, former mayor of Tynemouth, magically changed colours, but was covered due to repeated vandalism. Fencing removed during the war was replaced in the mid-1980s. The square now hosts the annual Victorian Christmas market with a Norwegian spruce donated by DFDS as its centrepiece.

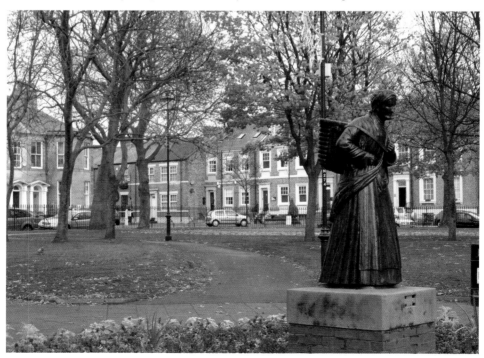

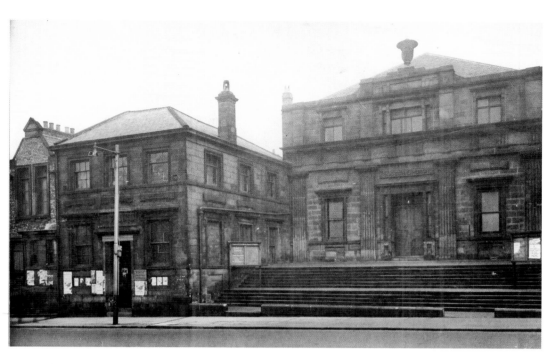

Salvation Army/Presbyterian Church

The railed building set back up the stairs is the Salvation Army headquarters in Howard Street. It was formerly the Presbyterian church, locally known as the Scotch church, and the building next door was the attached schoolroom, which was a forerunner of King Edward Primary School. Tasker Hall latterly belonged to Howard's Stores and is now used as studios by Stages School of Dance.

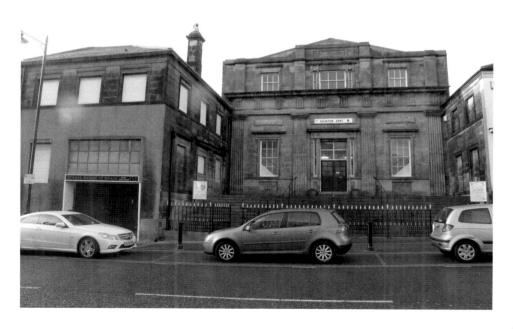

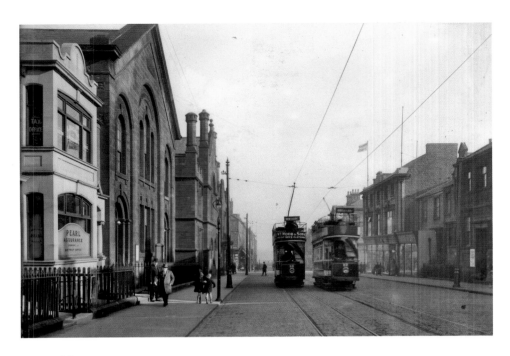

Howard Street

The Pearl Assurance and Tax Offices were on the left of Howard Street next to the town hall buildings. The United Methodist Free Church was built in 1856 to seat up to 650 people with a Sunday school building behind it. The church interior was dismantled at the end of 1938 to enable use by the borough treasurer's department. The tramlines ran along Saville Street then up Howard Street towards the square, which is the route taken by buses in 2013.

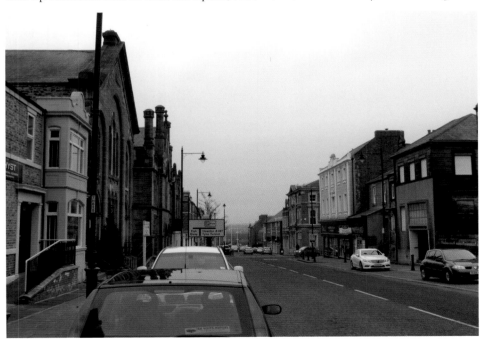

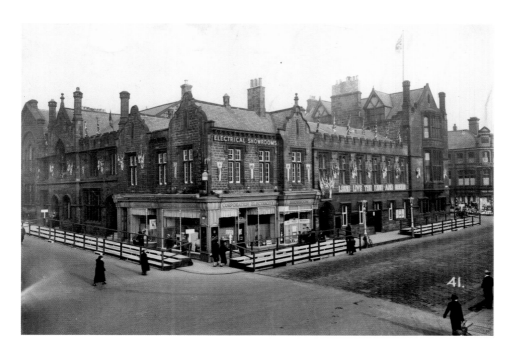

Royal Visit to Town Hall 1939
The municipal buildings and police courts are decorated with flags and bunting to welcome the visit of the King and Queen on 21 February 1939. Raised staging has been put out to ensure that the dignitaries have a perfect view of the royal party when they arrive. The corporation electricity showrooms can be clearly seen on the corner with the large picture windows where the current occupiers Saville Exchange and Hadrian Estates now operate.

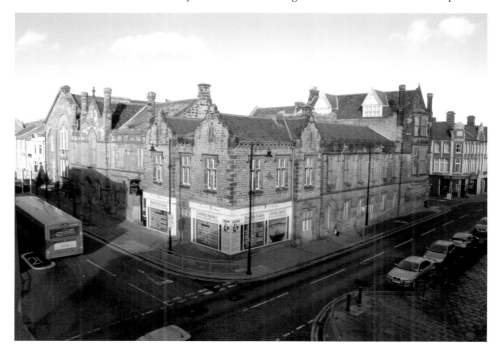

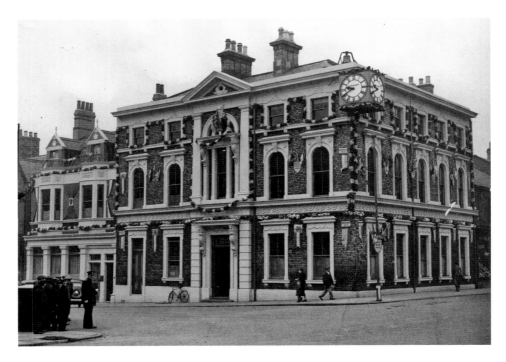

The Old Library Building, Saville Street & Howard Street Corner
Tynemouth County Borough Library was housed in the building at the corner of Howard Street and Saville Street. During the refurbishment of the 'new' North Shields Library most of the materials were temporarily moved back into the refurbished 'old' library building in December 2011. The new entrance on Saville Street was created for the business centre, which moved into the building when the Local Studies Centre was incorporated into the Central Library building in Northumberland Square in the 1980s.

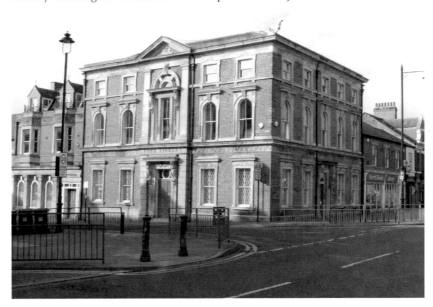

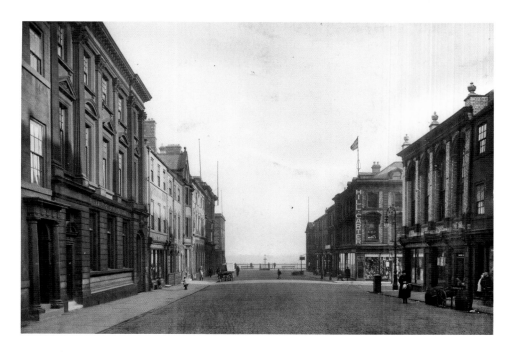

Howard Street

In 1928 three banks were on one side with Burton dyer's and Scott's confectioner's in-between. Hill Carter's stores were opposite and Welch's and Bainbridge's both had premises here. Old Royal Assembly Rooms became the Employment Exchange, the barrow was outside the paint stores, and Brough's grocer's was between Howard Hall Picture House and Borough Surveyor's office and library. The whole area was rebuilt in the 1980s. The DFDS ferry is passing the bottom of the street in March 2013.

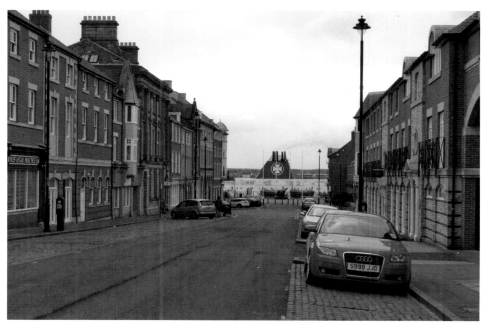

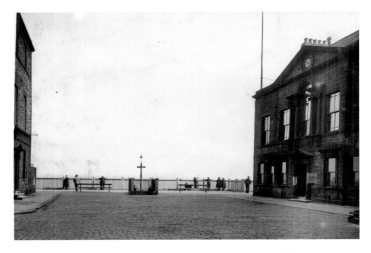

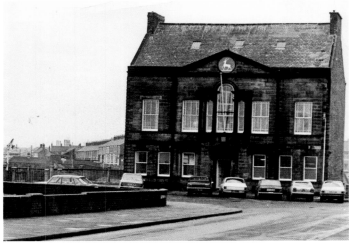

Maritime Chambers Register Office, Formerly Stag Line

No. 1 Howard Street was built in 1807 as the first subscription library in the north of England. In 1891 it became headquarters to the Joseph Robinson & Sons, from 1895 known as the 'Stag Line', and was their offices for ninety years. After a brief spell as a public house, Maritime Chambers is now the home of the registrar of births, deaths and marriages, providing a picturesque setting overlooking the River Tyne for register office weddings.

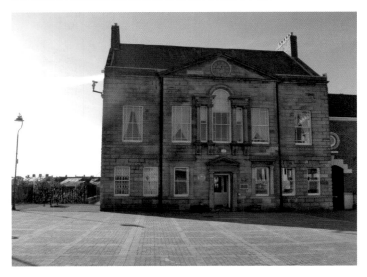

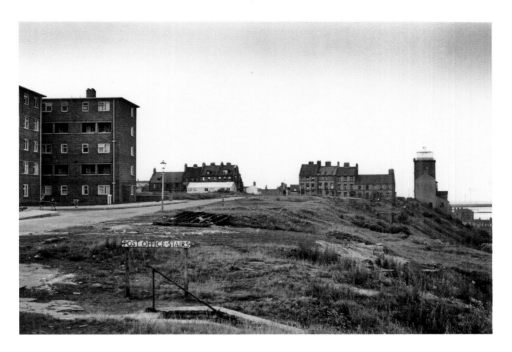

Tyne Street

A pleasant walkway leads along the bank top with the new houses on the site of the former Dockwray Square and later high-rise flats looking towards the King's Head, now the Wooden Dolly pub, and the High and Low Lighthouses, now painted white, towards the river mouth. The Tyne Court flats between Stephenson Street and Norfolk Street and the remains of Dockwray Square are both visible at the top of the Post Office Stairs leading down to the quayside.

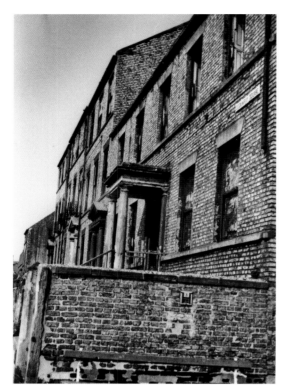

Dockwray Square

Begun in 1763 by Thomas Dockwray, vicar of Stamfordham, on land inherited from his father Josiah, a wealthy salt-tax collector, the dwellings for the well-to-do families of Dockwray Square were the first built above the riverside. The Old High Light of 1810 stands on the fourth side and is now a private residence. In decline by 1930s, the square was demolished to build high-rise flats in the 1950s. New private town houses in 1990s attempted to take it back to former glory.

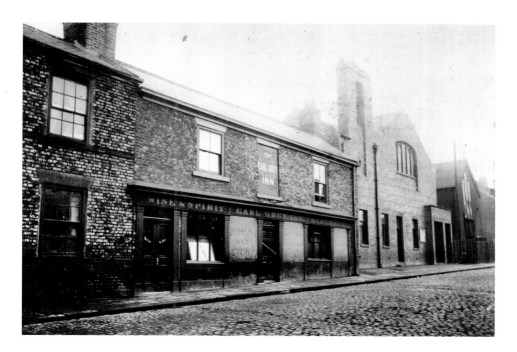

Earl Grey Inn & St Faith's Mission, Hudson Street

St Faith's, the earliest mission in Tynemouth parish, was built by residents of Dockwray Square. The church bell came from Henry Edward Pyle Adamson's barque *Amy Robsart*, wrecked on the Black Middens Rocks, presented to the previous iron church building in 1864. Earl Grey Inn is recorded on the 1841 census and in trade directories until 1938; St Faith registers continue until 1951. Dated around 1910 and then under demolition in 2012, the buildings were latterly used by Grange Interiors. *Bottom photograph ©A.H. Beautyman.*

Pilot's Lookout House

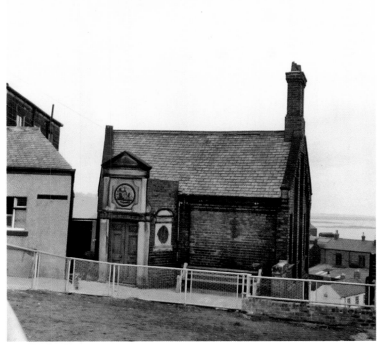

Next to the King's Head public house on the top of the bank along Hudson Street was the river pilot's lookout house. They could view the river from the top of the long stairs. The space is now used as a beer garden area for the pub, called the Wooden Dolly since 1983. On the right in January 2013 scaffolding surrounds the Old Low Light building as it is transformed as part of the regeneration project on the Fish Quay below.

Trinity Buildings, Beacon Street
Known as Trinity Buildings, these
five large houses, built in 1887 in
Queen Anne style, were red-brick with
stone facings. The land belonged to
Trinity Brethren next to the Old High
Light of 1727, which was turned into
almshouses when replaced by new
lights in 1810. 1950 Council Minutes
state that 'Dockwray Street Obelisk'
was 'not of sufficient architectural or
historic merit to be retained in the
statutory list'. The concrete obelisk
replaced the original 'Dolphin Beacon'.

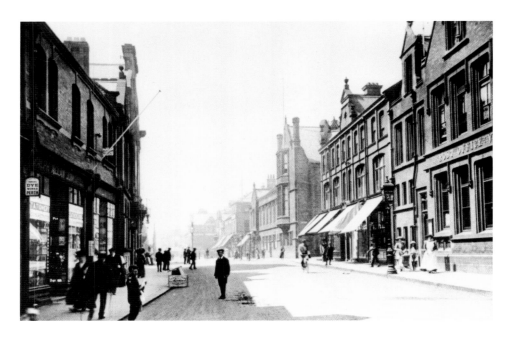

Old Post Office, Saville Street

The general post office was moved into the Co-operative building on Bedford Street but was originally at the east end of Saville Street. It was built in the time of Queen Victoria as shown by the sign 'Post Office VR'. A row of shops at ground level with Wellington Chambers above were next door, with the police station and courts in the town hall building. The shops on the other side of the road were demolished to provide sheltered housing.

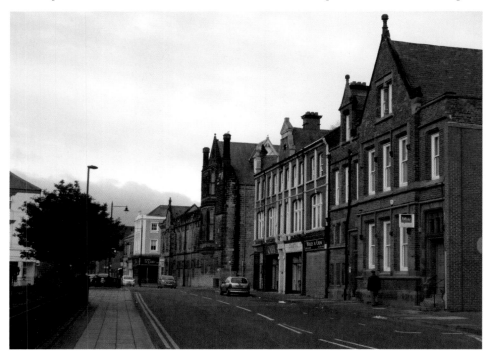

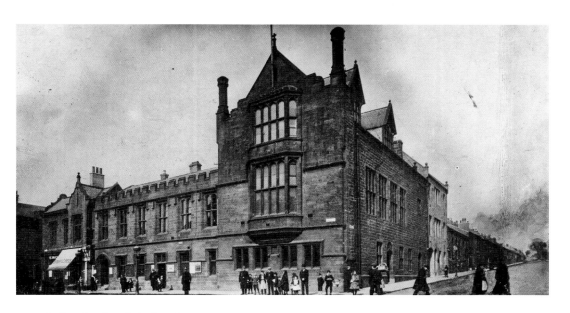

Police Station & Police Court

Built in 1844, the town hall building at No. 57 Saville Street housed the police station and police court, completed in 1845, as well as the council chambers. Tom Blackburn joined the Tynemouth police force in 1893 and became chief constable in 1920, until his retirement, after fifty-two years of service, in 1946. He was awarded the King's Police Medal for Distinguished Service in 1939 and the Order of the British Empire in 1944.

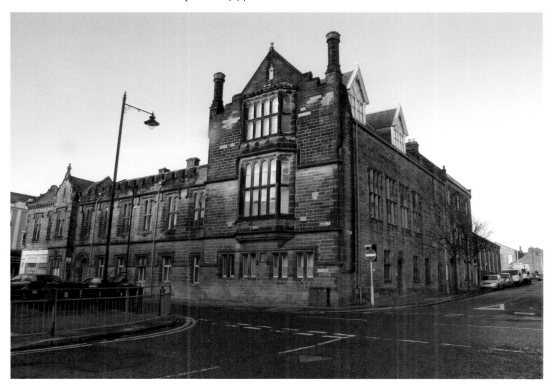

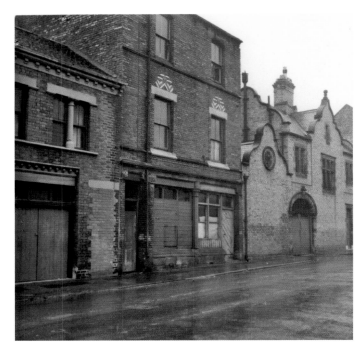

Lower Norfolk Street
Unusual dwellings were built at the bottom of Norfolk Street from 1 July 1859, surrounding the former stables belonging to Messrs Hodgkin, Barnett, Pease and Spence Bank at No. 105 Howard Street. The old, ornate building with the large doorway corresponds with the back of the bank building and No. 124 Norfolk Street is listed in directories as the residence of the bank messenger. The date 1883 is above the added window and a blue plaque marks the entrance to 'Bank Court'.

Old Fire Station, Norfolk Street

Once in the middle of a residential terrace, the fire station was originally the Union British Girls' School and was used by the fire department from 1906, shown here later as the weights & measures department. Hope Inn nearby was refused a license in 1959 and earmarked it for demolition in the regeneration process. Standing alone, now transformed into a public house, aptly named the Bell & Bucket, the rest of the building is garages.

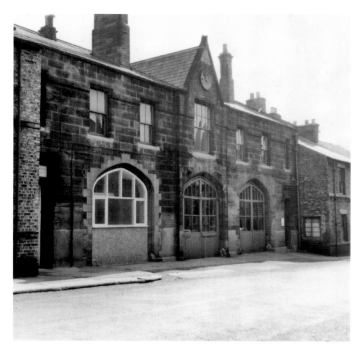

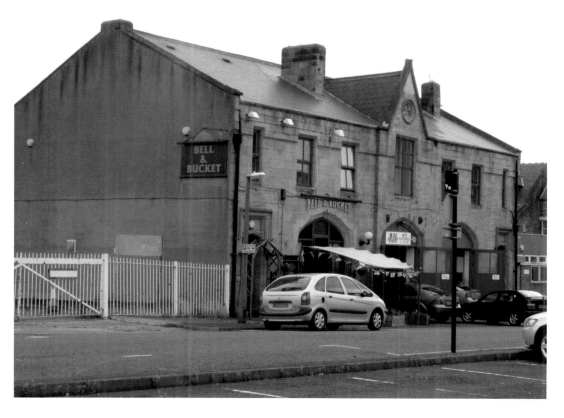

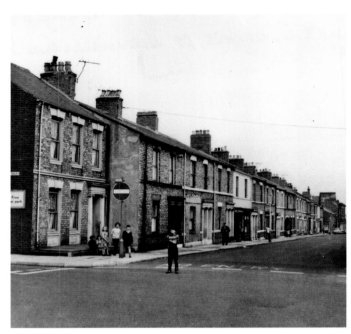

Northumbria House, Norfolk Street

On the corner with Suez Street, five-storey Northumbria House, the former home of the registrar, is now virtually empty and awaiting new tenants. Using a revolutionary German machine to pump in hundreds of tons of concrete for the foundations in just over three hours, it was the first office block built after the Second World War, costing £300,000. Boasting 24,000 square feet of office space, it replaced most of the terraces at the top of Norfolk Street.

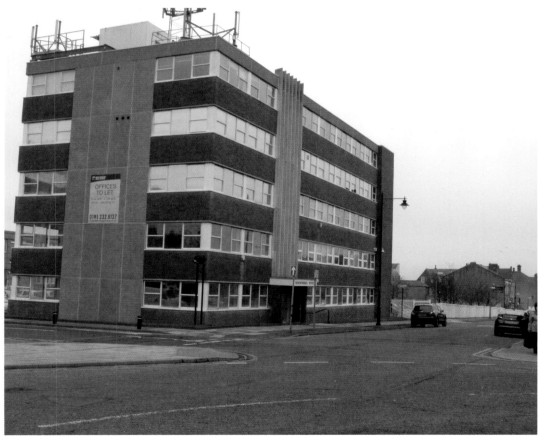

Stephenson Street
Hunter's bakery was formerly Yeeles' building shop and yard. From a small kitchen in Lawson Street, Hunter's business grew to include a ballroom seating 120 people above the shop. In 1980 William Hunter (North Shields) Ltd closed its doors at Verne Road, Preston Road and Stephenson Street with the loss of twenty-nine employees after seventy years of trading. Roslyn Hall was granted a licence and kept on by William's grandson then taken over by the RAOB Club, now closed.

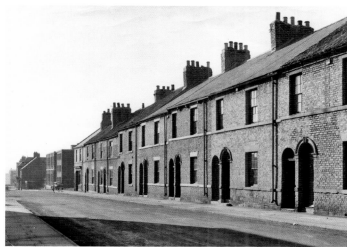

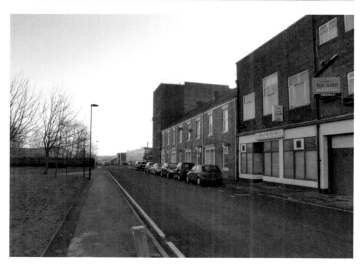

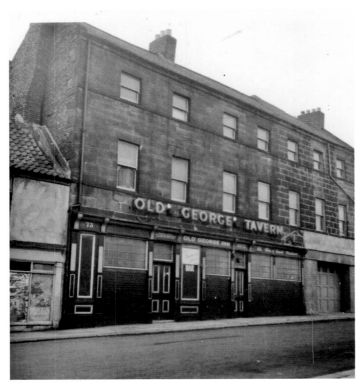

Old George, King Street
Old George Tavern at the Charlotte Street end of King Street was built by Justice Scott of Dockwray Square in 1793. Assembly Rooms above hosted functions and court proceedings until 1854. In 1859 it housed theTynemouth Volunteer Artillery. In 1861 it was a music hall, before becoming part of the temperance movement as Broadbent's Hall. By 1959 it was being used as a pigeon loft. Hastie D. Burton, builders, has been in this part of King Street, renamed Kettlewell Terrace, since 1903.

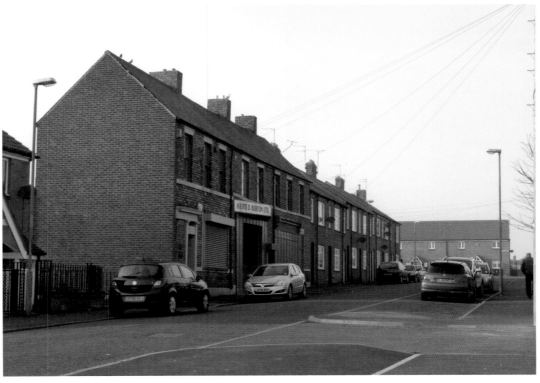

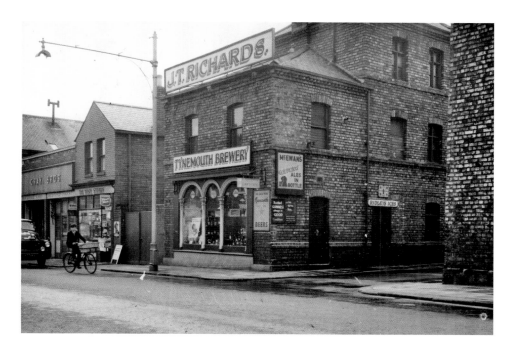

Tynemouth Road

J. T. Richards had the Tynemouth Brewery in Albion Road next to Gray Bros garage and the Handy Stores, with Ridley's Ices round the corner in July 1958. Mrs Cramman from Handy Stores took the day's takings home in a shopping trolley every evening. Tyne Forge has been in the Handy Stores building, making handcrafted iron curtain poles and wrought-iron furnishings since 1998. The brewery has been demolished and Dial Motor Company uses the land as part of their forecourt.

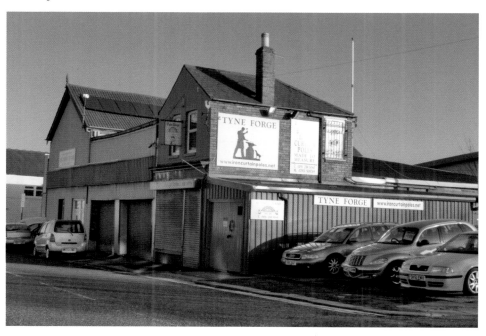

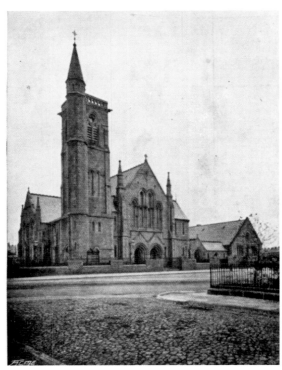

Memorial Methodist Church, Albion Road

Howard Street Wesleyan church moved into their new premises in 1891, funded by Joseph Robinson as a memorial to his daughter, although he died suddenly before building began. Following a decline in the building and the congregation, it was bought in 1981 by Byker Mission with a new lease of life brought by pastor and radio broadcaster Frank Wappat. Battling dry rot, vandalism and rising costs, it was sold to soft-play centre Koko's for children's parties. It is now Kiki's Kabin.

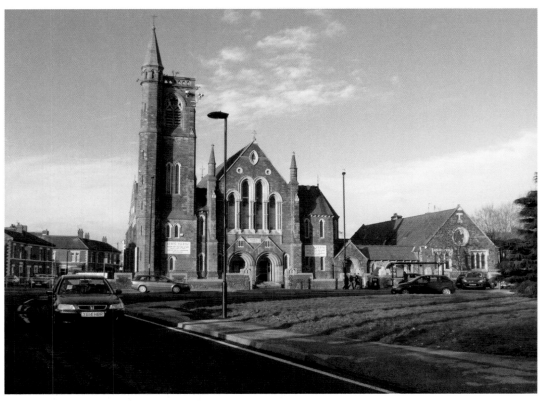

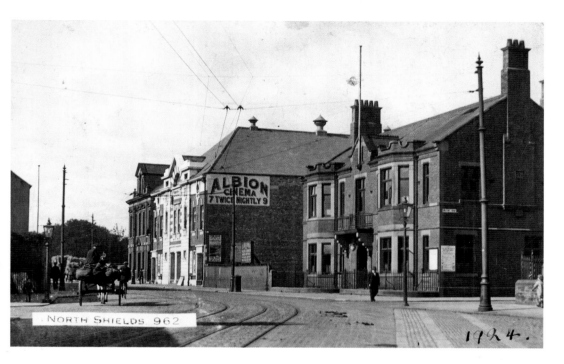

Albion Cinema and Unionist Club, Albion Road

The grand façade of the Albion Cinema is the centre of these three imposing buildings in 1924. The cinema and its neighbour Christ Church Hall have been replaced with the Masonic Hall and Norfolk Court modern sheltered housing. The Unionist Club still stands on the corner of Military Road. Today's busy traffic is a far cry from the slow pace of the horse and cart, bicycle and tramcar.

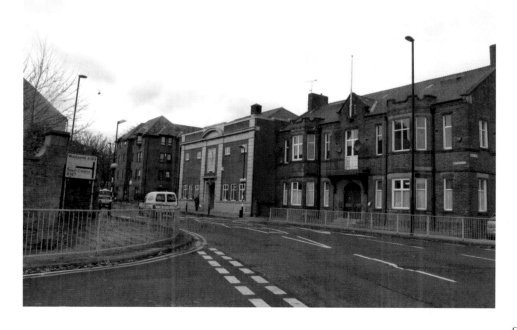

81

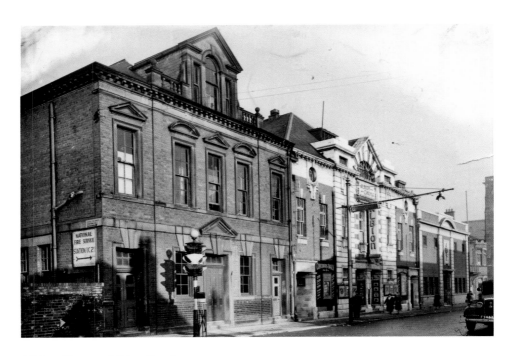

Albion Cinema, Albion Road

Norfolk Court sheltered housing stands on the site of the former Albion Cinema and Christ Church Hall. Tynemouth parish hall signpost points to the National Fire Service station, now the Bell & Bucket pub in Norfolk Street. The Masonic Hall and Unionist Club are still there and the tower of Memorial Methodist church is just seen. The Albion, a purpose-built cinema, opened in 1914 and closed its doors in 1976. The longest serving member of staff was William Reith, projectionist for thirty-three years.

Christ Church School from Albion Road
The 'new' Christ Church Primary School was officially opened and dedicated on Friday 6 May 1966, to coincide with the date the original school began in 1872. It was abandoned during the Second World War due to lack of shelter facilities for the children and left to decay until a fire broke out in 1959 and it was demolished. Although the capacity of the new school was 320 children, it opened its doors to just 28 pupils.

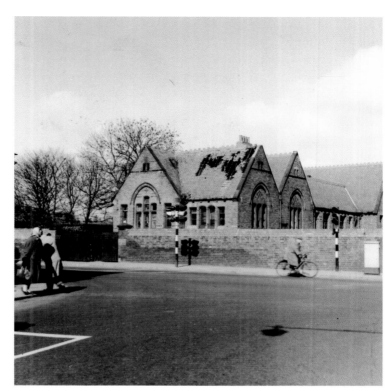

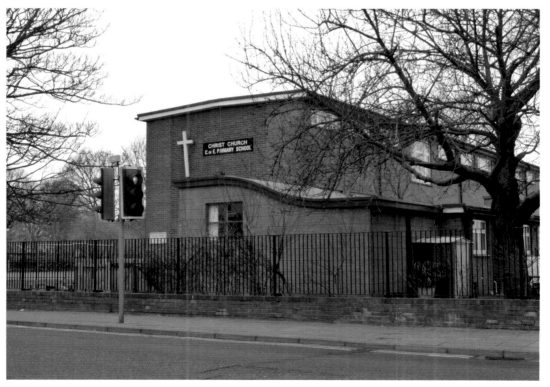

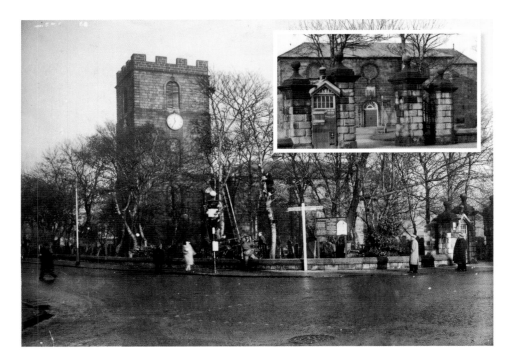

Christ Church

Passers-by are watching the men up ladders in the trees, possibly cutting off damaged branches, in 1946. It is possible to clearly see the police box sitting snugly between the gateposts of Christ Church graveyard entrance on Albion Road. In the 1920s, twenty-three police boxes were put up so that officers could ring in at the start of their shift. A newer box was added 1960s, but now there is no evidence that they were ever there.

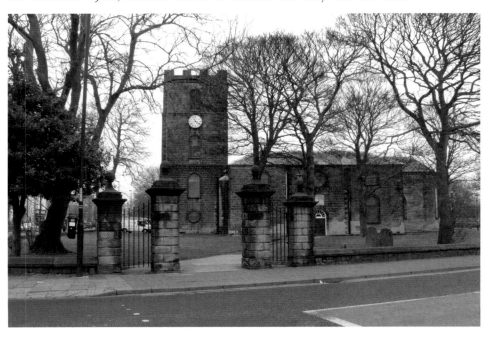

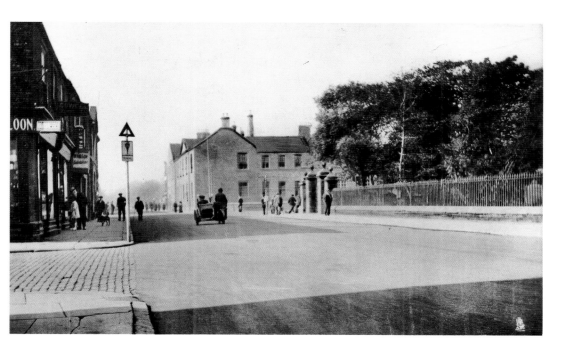

Jubilee Corner, Albion Road

Royal Jubilee School, erected in 1811, closed in 1935. It suffered some bomb damage in the Second World War; part of it was used as a British Restaurant in 1949. Many local school children will remember learning to swim here with Mrs Richardson. The building was demolished in 1971. A monument to Thomas Haswell was erected in Jubilee Corner in 1989, 100 years after his death, on the site of the school where he was the 'Maister'.

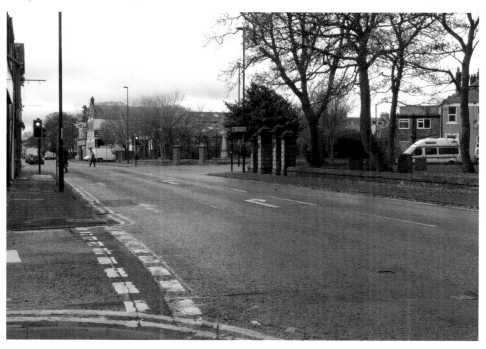

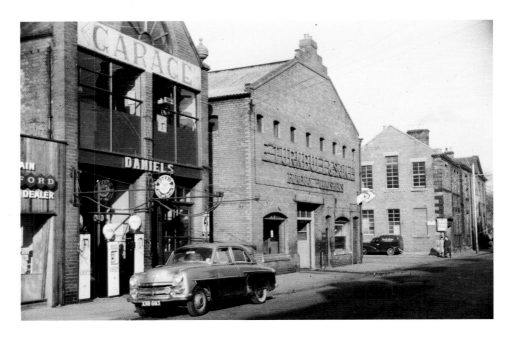

Royal Jubilee School, Albion Road

Beyond Daniel's Ford dealership and Turnbull's Garage stood Royal Jubilee School. One of the oldest schools in the region it opened in 1811. Former pupil Thomas Haswell became the 'Maister' in 1839. He died in 1889 aged eighty-two, only three years after retiring as headmaster. The Haswell Medal for academic achievement since 1890 is still awarded annually. It closed on 31 May 1935 and pupils went on to the newly opened Ralph Gardner School.

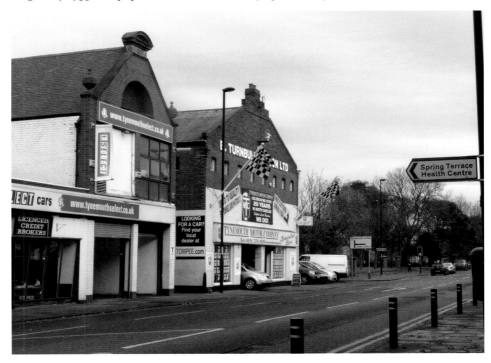

Albion Road

St Cuthbert's church opened in 1821 at the top of Bedford Street. The congregation moved along Albion Road West into the new church and parish centre in 1975. The residential care home Edith Moffat House now takes up the site of the old church, named after social housing pioneer for homeless women in North Shields and Tynemouth, Edith Moffat 1860–1952. The Olde Hundred public house just beyond was at No. 100 Church Way before the street was renumbered, hence the name.

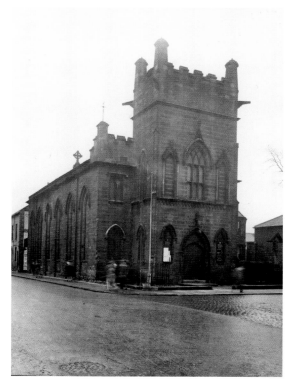

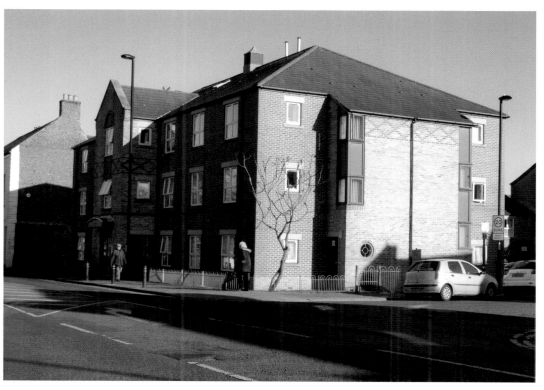

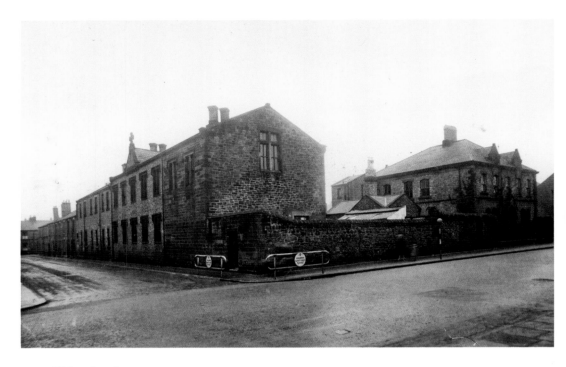

Albion Road

St Cuthbert's Roman Catholic School was built in Nelson Street in 1840. Shown in 1946, with the distinctive pointed apex bearing a stone cross, it was originally off Albion Road before moving down Coach Lane to its present site in Lovaine Place. In 1968, planning permission was given to build the Catholic Men's Club on the site, with access from Cecil Street, behind the former convent on the right, extensively restored as a special housing complex beside new offices and studios.

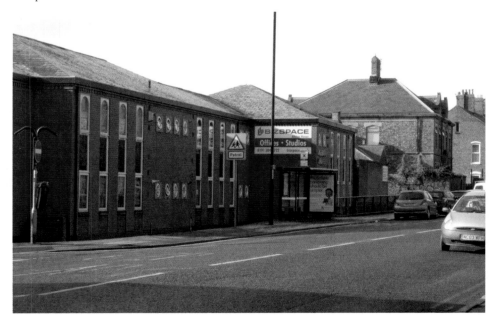

Albion Road Health Centre
The newly built Health Department in Albion Road was underway for opening on 17 May 1960, with all mod cons for dentistry and clinics. It has since bedded down into its surroundings with a car park in front, where a paved area originally featured the pram park outside the baby clinic entrance.

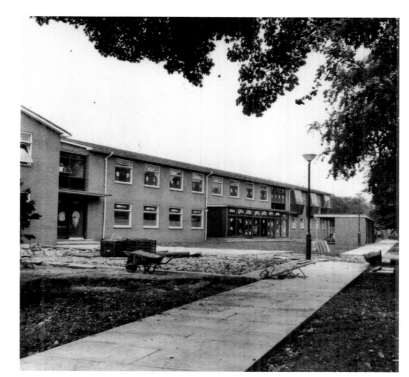

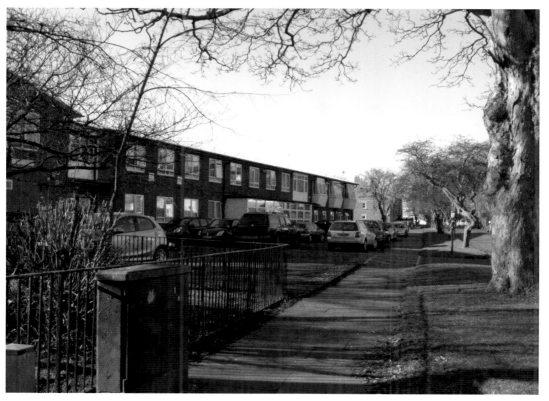

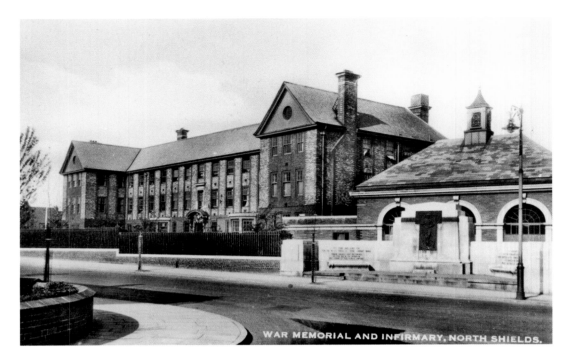

WAR MEMORIAL AND INFIRMARY, NORTH SHIELDS.

Hawkey's Lane War Memorial

The First World War memorial erected in 1925 is part of an extension to Tynemouth Victoria Jubilee Infirmary in Hawkey's Lane. Only the memorial building, now used as an ambulance station, and the cenotaph remain, and the doctors' surgeries and chemists are on the site of the hospital clinics.

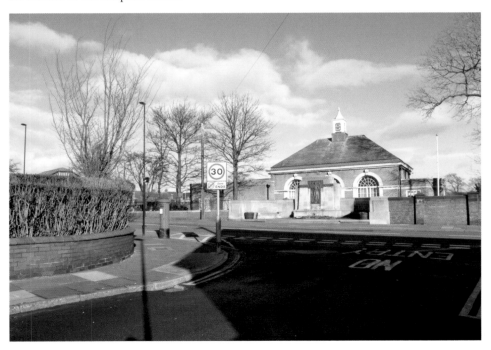

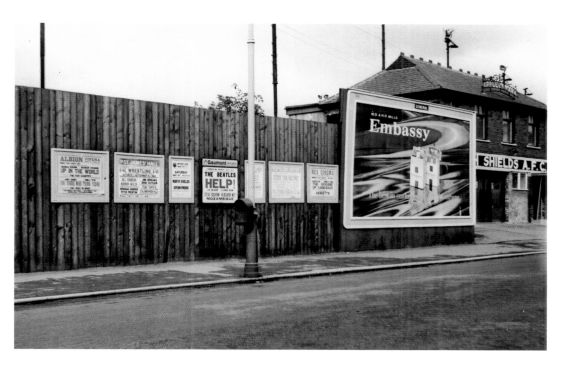

Appleby Park, Hawkey's Lane

Once the home of North Shields AFC, Appleby Park ground in Hawkey's Lane is now a housing estate, but still retains its iconic name. The football club now trains and plays on Collingwood Field, Chirton. Photographed by the borough surveyor's office in September 1965 as part of an inventory of advertising spaces, the billboards show the Beatles film *Help!* at the Gaumont, *Up in the World* at the Albion and *The Brigand of Kandahar* at the Rex cinemas.

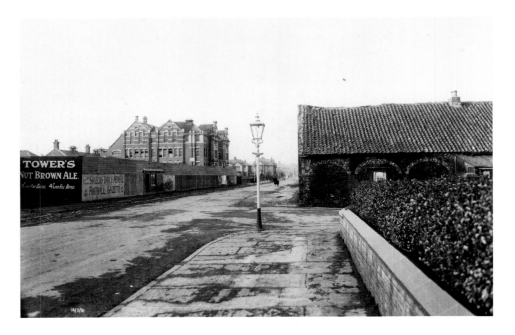

Hawkey's Lane

Kennel's Farm is on the right of Hawkey's Lane looking beyond Appleby Park towards Tynemouth Municipal High School. Mr Storey had the three-roomed cottage, shop and farmyard at the top of Cleveland Road, so it was known locally as Storey's Farm. After Mr Storey died, his widow married Walter Thompson who remained at the farm until 1927. It was demolished in 1931. The Cleveland Road Co-op store, formerly Alldays and before that the Freezajoint, is now on the site.

Collingwood Arms Hotel

The Collingwood Arms in Chirton was built on a much grander scale than the Old Collingwood Arms from 1828 nearby in 1937. It stood at the corner of Billy Mill Avenue and Front Street, Chirton, until 2005 when it was replaced with Collingwood Court, a purpose-built three-storey residential care home specialising in Alzheimer's and other forms of dementia.

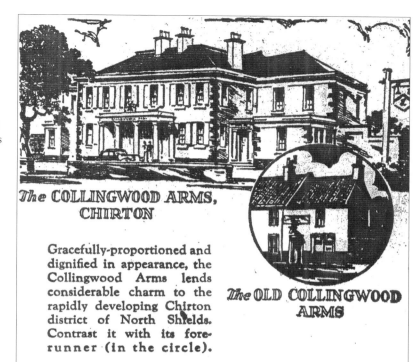

The COLLINGWOOD ARMS, CHIRTON

Gracefully-proportioned and dignified in appearance, the Collingwood Arms lends considerable charm to the rapidly developing Chirton district of North Shields. Contrast it with its fore-runner (in the circle).

The OLD COLLINGWOOD ARMS

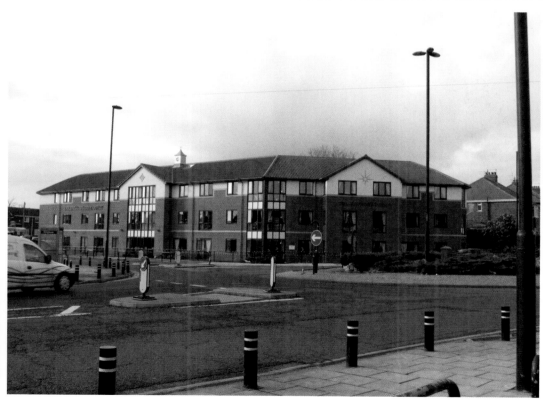

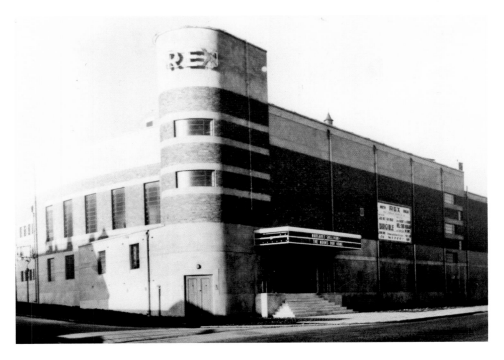

Rex Cinema, Billy Mill Avenue

The Moon's Our Home was a 1936 film starring Margaret Sullavan and Henry Fonda, advertised as the feature above the entrance to the Rex Cinema in Chirton, which opened in December that year, hailed as 'Chirton's luxurious new entertainment centre'. The Co-operative funeral parlour stands on the site, the Rex being demolished in November 1996 after standing derelict for some years.

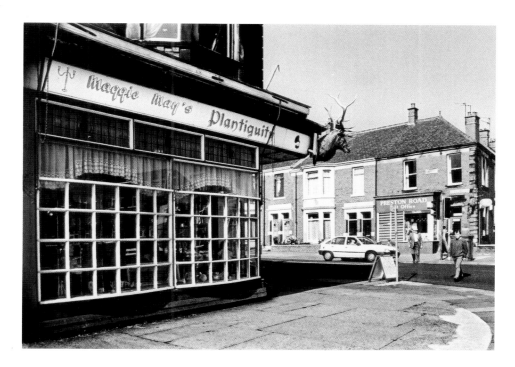

Kirton Park Terrace, Preston Road

Jem Hair Design is relatively new to the bottom corner of Queen Alecander Road, the former site of Maggie May's antique shop, which was sited here until 1988. When the sign for the shop on the other side of the road was being printed for change of use, a ghost sign for a private circulating library was uncovered. The accountancy firm on the opposite corner was previously Preston Road post office.

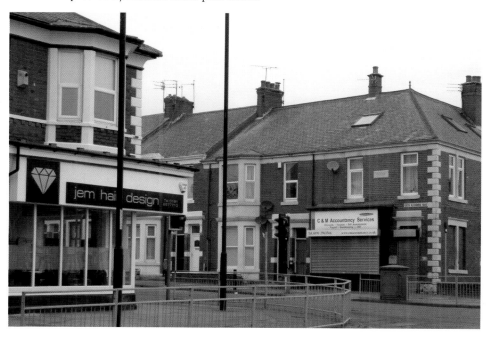

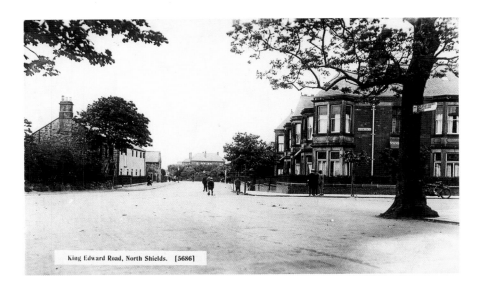

King Edward Road, North Shields. [5686]

King Edward Road

In 1877, Alderman Shotton successfully moved in council that Cut Throat Lane be renamed Preston Avenue. Spital Dene Road is now King Edward Road; it was named for Edward VII. On the corner beside the golf course, just past the Linskill Centre, formerly Linskill School, is the site of the farmhouse to Spital Dene Farm, once owned by the Nelles family, which covered over 70 acres of land. On the 1861 census, George Nells is the farmer, and by 1871 his widow Hannah is in charge.

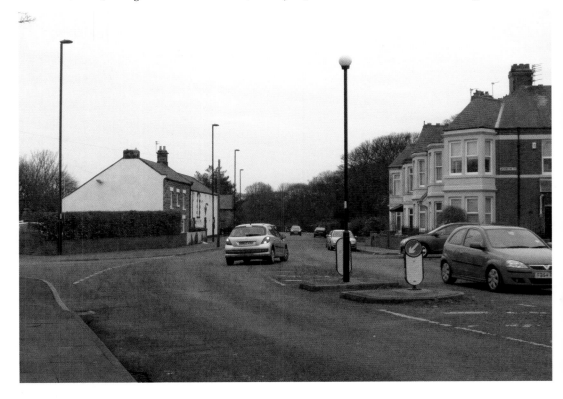